778.3 ROUSE, ANDY Digital SLR handbook

Digital SLR HANDBOOK

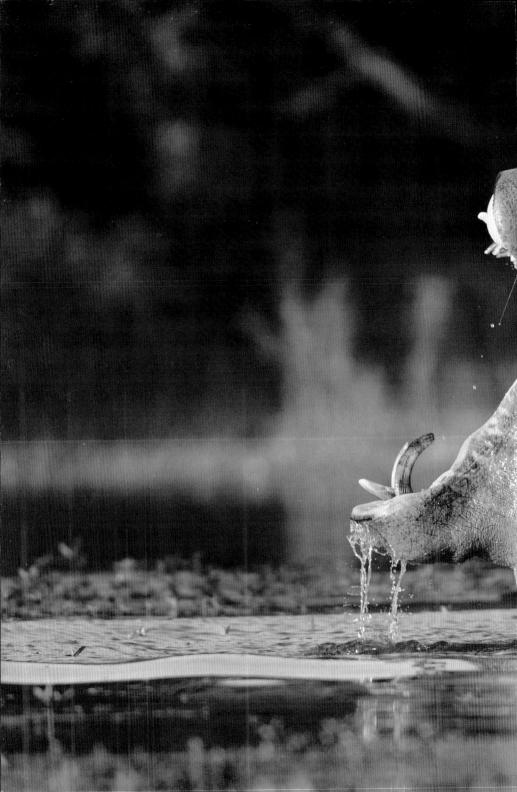

Digital SLR HANDBOOK

Andy Rouse

ST. CHARLES PARISH LIBRARY 105 LAKEWOOD DRIVE P.O. BOX 949 LULING, LA 70070

> photographers' pip institute press

First published 2005 by **Photographers' Institute Press / PIP,**

An imprint of GMC Publications 166 High Street, Lewes, East Sussex, BN7 1XU

Text and photographs © Andy Rouse 2005 Photographs on pages 11 and 90 © TJ Rich 2005 Copyright in the Work © Photographers' Institute Press

ISBN 1861084250

All rights reserved

The right of Andy Rouse to be identified as the author of this work has been asserted in accordance with the Copyright Designs and Patents Act 1988,

Sections 77 and 78.

All trademarks are the property of their respective owners. Many of the designations used by manufacturers and sellers to distinguish their products are claimed as trademarks. Where Photographers' Institute Press was aware of a trademark claim, they have been printed in capitals or initial capitals. No such use, or the use of any trade name, is intended to convey endorsement or other affiliation with the book

No part of this publication may be reproduced, stored in a retrieval system, or transmitted in any form or by any means without the prior permission of the publisher and copyright owner.

The publisher and author can accept no legal responsibility for any consequences arising from the application of information, advice or instructions given in this publication.

A catalogue record of this book is available from the British Library.

Production Manager: Hilary MacCallum
Managing Editor: Gerrie Purcell
Photography Books Editor: James Beattie
Designer: JoPatterson.com
Illustrations on pages 24–5, 27, 34, 49–50, 86–9 and 123 Fineline Studios

Typeface: Frutiger
Colour origination by Icon Reproduction, London
Printed by Hing Yip Printing Co. Ltd. China

About the author

Andy Rouse is a world-renowned wildlife photographer who has long had a passion for wild things. He has built his reputation on getting close, in fact very close to some of the world's largest and most dangerous animals; in doing so, capturing some of the most exciting and evocative photographic images of wildlife found today. With a style all of his own, Andy is equally passionate about the message that his images convey and sees his work as contributing to the general appreciation of our precious wildlife, hopefully stimulating us all to act on their behalf.

A true professional, Andy has made numerous TV appearances (including in his own series Wildlife Photographer and on BBC1's Countryfile), writes regular columns for magazines, has his work published worldwide, runs regular

workshops and tours to exotic places and has authored several books including *Life in the Wild:* A Photographer's Year.

More of Andy Rouse's work can be seen at www.andyrouse.co.uk

Acknowledgements

Special and heartfelt thanks must go to the following people; they have helped, supported and encouraged the production of this book:

PVV (for being my digital inspiration); Andrew Jackson (ACTPIX); Andrew James (PP); Colin "moth goth" Langdon (Adhoc Hairdressers); Howard Utting and Ainsley Wilkins (Warehouse Express); Michael and Kenneth; Safdar Zaman and Barry van Vuuren (Canon); Andy Bennett, and finally all those involved in this book at PIP especially James Beattie for his patience!

Contents

Introduction 8

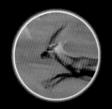

1 The digital advantage 12

2 **Technical operation** 22

3Choosing RAW or JPEG 48

Setting up your D-SLR 60

5 Field exposure guide 80

6
Managing your
D-SLR in the field 92

7

The digital darkroom 102

8
Storage, cataloguing and distribution 126

Glossary 138
Appendix 141
Index 142

Introduction

Welcome to the digital age. Whether you like it or not, the world in which we live is a digital one and photography is moving ever further away from film. Most commercial photographers are now entirely digital: press and sports photographers send pictures to their newsdesks from around the globe within minutes of an event, and even wildlife photographers like me have made the jump.

There is a tide of photographers who want to make the switch from film to digital, but a wealth of unanswered questions that stops them in their tracks. As in politics, there is a lot of hype and

misinformation about digital capture, and often technical jargon is used where simpler language would suffice. Similarly, some of the parties involved seem happy to trade insults that would be more at home in a political campaign than a reasoned discussion. To cap it all, the digital world has more acronyms and confusing terms than Bill Gates has dollars, so it is no wonder that people get confused. This book concentrates on the issues of digital capture with a digital SLR (or D-SLR) and not on digital manipulation. It is not that I am against it (far from it), but I am not a PhotoShop expert; I am simply a

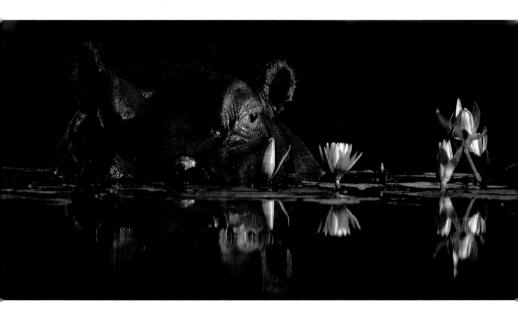

working professional photographer who uses a D-SLR for all of his work. I was the first photographer at any of my agencies to submit, have accepted and sell digitally captured images. I use D-SLRs on a daily basis in a professional capacity to get good pictures, and I have learnt that although at first glance they appear to be complex, they are actually not that different from the film cameras that I used before. In fact, the major difference is one of approach rather than technology.

If I were asked to write an encyclopedia of digital imaging, I'd refuse. The subject is too diverse, with so many varied and conflicting opinions. However, although there is a lot to learn about digital photography, you do not need to know everything to use a D-SLR.

This book has been written in a way that sticks to the facts and looks at the whole subject from the position of the photographer. Of course, there are technicalities, which I will cover where necessary, but knowing the cause and effect is a lot more useful than knowing about the bits and the bytes. It is too easy to get lost in the technology of digital capture and forget what photography is really about: taking great pictures. Many existing film users may start to read this book with some trepidation, concerned by the changes that it will make to their photography. Well, don't worry; I'll show you how your D-SLR can be

set up to work in the same way as your film camera and produce a finished image straight out of the camera. Digital photography offers many creative advantages to the photographer, and this book will help you to find out what it can do for you.

In truth, digital photography has been with us for many years. Most professionals realized long ago the benefits of sending out scans on CD instead of valuable originals. Initially, however, clients viewed anyone sending images on CD with suspicion. We were often labelled as image manipulators. My reasons for switching to a CD-based library were simple: I could save money on duplicates (which soon mount up when you use several stock agencies) and protect my valuable originals from damage. It often takes me weeks of effort to get one shot, and it is all too easy to drop the resulting transparency into a mug of coffee or run a fingernail across it. Hence the attraction of using CDs to store images.

Gradually the market has changed and sending out images on CD has become the accepted way of doing business. It makes sense for clients, as having valuable originals in your possession is an insurance nightmare. It also removes the middleman, as previously the slides would need to be scanned by a repro house, then the scans would be returned for inspection before being sent back again to the repro

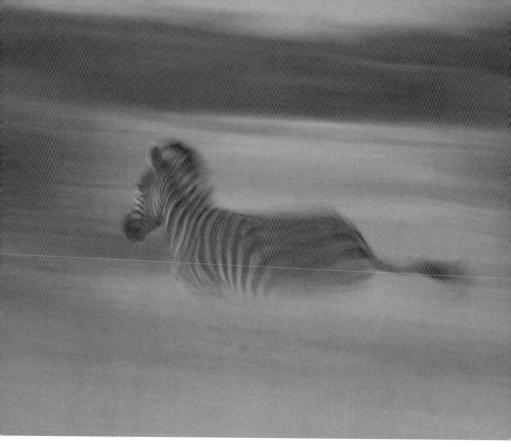

Above My client wanted abstract images that described the characteristics of the subject. Zebras are born to run, so it seemed natural to me to blur their motion. Experimenting with film would have been costly and uncertain, but with my D-SLR I felt confident to try it.

house. Now, with scans on CD, the need for this middle stage has been removed, admittedly at a cost to the photographer as we have to do the scanning ourselves.

Of course, the next logical step was removing film altogether and using digital capture. Studio photographers were the first to make the move, with digital backs being produced for their existing medium-format cameras. The first D-SLR was released onto the market several years ago and immediately started the greatest dilemma that the photographic world has ever experienced. To 'go digital' or stay with film has become the most important question since 'does Pepsi taste better than Coca-Cola', and it is as relevant for amateurs as it is for professionals.

Urged on by press colleagues, I started toying with digital capture as soon as the first consumer D-SLR was released. I quickly realized the benefits to my work, but was nervous about making the change, as none of my nature-photography colleagues seemed interested in it. The resolutions of the first D-SLRs were too small for my clients, although later we both realized that this was not entirely true. Soon my D-SLR images started to sell, and I started to use a D-SLR alongside my Pentax 645 NII on important trips. Everything changed when I was commissioned to record the rebirth of a South African national park, on the condition that all of my work was shot on a D-SLR. This was partly to reduce overheads, as my bill for 2,500 films for the year could be used instead to reintroduce extra animals into the park. As a conservationist, the choice was obvious and I shot the whole project digitally.

I soon began to realize the benefits of using a D-SLR and now my 35mm film cameras are stored away in boxes. While I still use my medium-format Pentax 645 NII for the occasional landscape shot, my digital sales now far outstrip my film ones and my decision has been wholly justified.

Below A lovely shot of a young hyena pup taken using a 4MP EOS 1D, which has captured excellent detail in the lateevening light.

Photograph © T.J. Rich/ARWP Ltd

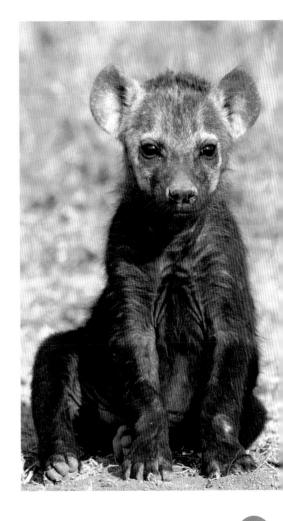

The digital advantage

There are many factors that lead me to believe that a D-SLR will not only improve your photography, but also make it a lot more fun. This chapter takes a look at those elements and also answers the important question: 'is digital better than film?'

For years amateur and professional photographers alike have used 35mm film SLR cameras. The benefits of such a flexible system are still there for D-SLRs, it's simply the medium that has changed. However, using D-SLRs also has some advantages that can make a tremendous difference to your photography, so let's take a look at some of them.

Instant review of images

Polaroid cameras (and Polaroid backs for medium-format cameras) have been around for a long time. The ability to see and change the effect of lighting, composition and filters before taking the final shot always struck me as a great advantage. The only problem with the Polaroid technique was that it took a few minutes for the prints to develop, by which time the scene would have changed (studio photographers excepted, of course). A D-SLR gives you a real-time Polaroid capability via its rear LCD screen, which allows images to be reviewed within seconds. Although these screens can mislead the unwary, used correctly they can improve your success rate significantly (see pages 85-91).

No more running out of film

Any photographer knows that whenever you are changing film, the best shot will happen. I am going to cover 'digital film' a little later (see pages 38–9), but for now

just appreciate that depending on how you set up the D-SLR you can get huge numbers of shots on each 'digital film'.

Environmental issues Using a D-SLR is much more environmentally sound than throwing away thousands of unused slide films, mounts, plastic sleeves and canisters – all of which end up being buried somewhere. A D-SLR produces no waste and, what's more, the 'film' is reusable. We only have one Earth and they aren't making another one, so we all have to care about this important issue.

It's more fun Switching to digital capture has rejuvenated many photographers' interest in photography. With no extra financial cost after purchase, you are free to take as many pictures as you like, and many amateurs increase their output as a result.

Financial savings The financial savings begin from the moment you start using your D-SLR, and I know a lot of photographers who have changed to digital capture for this reason alone.

I estimate that I saved thousands in processing, mounting and drumscanning costs alone in the first year. I asked several amateur photographers who still use film how many rolls they shot on average per year. The lowest was 100, and as things stand, at the time

of writing, the cost of purchasing and developing this number of films is more than the cost of a new consumer D-SLR. Most accept the same lenses as film cameras, and the only extra expense will be the one-off purchase of a memory card and a few CDs or DVDs. If you scan and print your work now from film, you will probably need no more equipment to step into the digital world. The one saving that you can't put a price on is time, and D-SLRs can save you loads of it.

Instant change of parameters

Lighting conditions change, and we have all been caught with the wrong film in the camera at some stage. In some countries the weather is so changeable that I have often thought of having two cameras, one for cloudy days and one for the occasional sunny one. The beauty of a D-SLR is that parameters such as ISO rating are treated differently for each shot, and can be changed from one minute to the next without any effect on the images already captured. You no longer have to carry a marker to highlight pushed films, nor panic when you drop an important pushed film into a bag of. normally rated ones and have to do an expensive clip test of the lot.

Many other parameters can be changed for each shot, such as the white balance, which allows you to shoot indoors without carrying bags of correcting filters. I make use of this ability to change parameters all the time, and now it is second nature. In fact, I wonder how I ever managed with film.

The skill of digital Some people believe that digital capture takes the skill out of photography; it doesn't. A D-SLR does not make a picture easier to visualize or compose. All it does is let the photographer see how the meter exposes the scene, and make corrections before it's too late.

As a travelling film photographer, I would often have to wait weeks to see results, with no chance of an immediate re-shoot if I made a mistake. To be honest, my 'near misses' file contained some real shockers. With the D-SLR I can instantly review the shot, delete it if it's poor and then re-shoot – all while still on location.

Imagine you were covering an Olympic sprint final and got the exposure settings wrong. Could you ask them to run it again? Using a D-SLR enbles you to determine the exposure beforehand so that you can concentrate solely on getting the shot. The bottom line is that with a D-SLR you can confidently capture images as they happen. In what way is that removing the skill from photography?

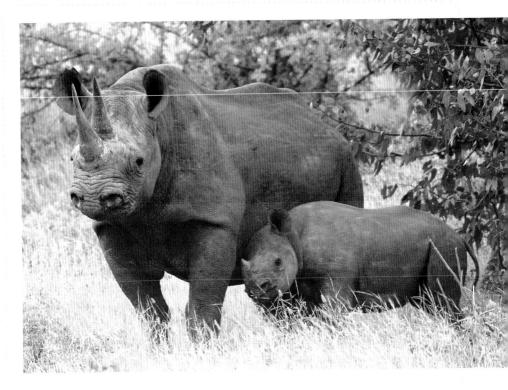

LCD screens have other, less obvious advantages too. Consider this picture.

This is a rare shot of a desert black rhino with its calf, taken in a remote area of Namibia called Damaraland. After several days tracking, I found myself in a deep rocky gully with a mother and calf rhino some 330ft (100m) away. This was a very unusual encounter, with the mother being completely unaware of our presence, and for our safety it needed to stay that way. Using the LCD screen on my D-SLR, I checked the exposure, focus

and composition of my first image, made corrections and shot about 20 variations. I knew that I had the images in the bag, so I made a hasty exit, already thinking of the cold beer that awaited me.

Using a D-SLR gave me the confidence to depart before the rhinos learnt of our presence, saving stress all round. With a film camera I would have kept taking bracketed sequences and would have been faced with a noisy film rewind, which may have ended with me on the sharp end of a rhino's horn.

DISPELLING THE MYTHS

The D-SLR has already been the subject of many myths, and here are two common ones:

1. With digital you can cheat and change an image if you want

The misconception seems to be that by using a D-SLR to capture images, you can 'cheat' and manipulate them. Granted, a variety of tools can be used to manipulate the image to the limit of your ability. However, the same possibilities exist with a scanned film image - once in digital form it is subject to the same rules as a digitally captured image. The difference is simply that a D-SLR image is already in digital form, while a transparency/negative will lose some of its quality when it is converted into the same medium. At the end of the day, it is your

views about manipulation that govern this, and not the medium that captures it.

2. With digital you can just point and shoot because tools like PhotoShop allow you to correct anything

While it may seem that you can brighten the darkest picture and vice versa, there is a limit to what can be achieved with software. If you do not have the detail in the image in the first place, no amount of editing can put it there. You also need to realize that any form of re-touching begins to degrade the image, so you want to use the minimum amount of correction. Also, we all have better things to do than sit in front of a computer screen.

Is digital better than film?

As I have already said, a D-SLR offers myriad advantages to the photographer. But the question always reverts to a simple one: 'is the quality of a digitally captured image as good as a film image?' My opinion is that the latest range of D-SLRs are more than equal to film in terms of quality.

As a professional photographer I depend on my clients to pay my bills, if they don't like my images, I don't eat! So if the images are good

enough for them, and good enough for me, they should be good enough for you. This might seem controversial, especially to committed film users, so I will now show you some hard facts, and explain a little of the terminology at the heart of a D-SLR.

Pixel basics The heart of every D-SLR is the sensor, the tiny element that converts the real world into digital form. Think of the sensor as the film plane and you have the

general idea, in fact it sits in the same place. The sensor is a waferthin array, comprised of millions of light-sensitive photodetectors, arranged in a grid. These points are referred to as pixels (PlCture ELements) and are the building blocks of digital photography. (In truth the pixel is actually a combination of the photodetector and its associated circuitry.)

Resolution The more pixels that you have in an image, the greater detail it will contain. There is also another school of thought that says it is not the quantity of pixels, but the size and quality that is important. The number of pixels in an image, whether digitally captured or scanned, is called the resolution. An image with 3072 x 2048 pixels will have more detail, and therefore produce a sharper result at the same print size, than the same image with 2048 x 1365 pixels. Three different resolution settings are shown (right).

The maximum resolution a D-SLR sensor can achieve is usually expressed as the absolute number of pixels in the grid rounded up to one decimal place. For example, a grid of 3072 x 2048 pixels gives a total number of 6.29 million pixels, or 6.3 MegaPixels (MP). This has become the de facto standard with D-SLR manufacturers when quoting their highest resolution. The higher the resolution, the bigger the image will print without showing pixels.

Above 3072 x 2048 pixels

Above 2048 x 1365 pixels

Above 500 x 333 pixels

Many photographers know that film structure is based on grain. The higher ISO film you use, the more grain can be seen. One thing is sure though – for most of us, pronounced grain in an image is completely unwanted. A digitally captured image, by its very architecture, is based on digital information and cannot therefore suffer from grain.

It can, however, suffer from signal noise, which can have a similar effect to grain in film. Fortunately, the latest D-SLRs have addressed this issue to produce virtually 'noiseless' images.

The IQ test Norman Koren and Miles Hecker have produced a mathematical analysis of this comparison. I want to thank them for allowing us to reproduce it here (for more information, see the appendix on page 141). They compared a digitally captured image with a scanned film image, in terms of its inherent image quality (tonal range, detail, sharpness, signal-to-noise ratio). Using a mathematical model, they came up with a single value called the Image Quality (IQ). The table below shows a summary of their findings.

So what does it all mean? Well, let's take the film results first. The effective pixel array for a 35mm film

(IO)

1.03

0.76

1.18

nage Quality
0.73
0.84
1.75
0.54
0.78

11.0

6.0

13.7

Canon 1Ds

Nikon D100

Kodak 14n

TABLE

camera is clearly much higher than that of the largest D-SLR at the time of writing. But, as I have mentioned, the effect of grain and of the pure digitized form of the image must be taken into account; even though the slide films have more inherent detail and colour range, the effect of scanning them increases any grain in the scanned version, and therefore degrades image quality.

Looking at the IQ figures (opposite), it is clear that a Canon D60 or Nikon D100 (with IQs of 0.78 and 0.76 respectively) compare very favourably with a scanned 35mm Velvia 50 or Provia 100F image. Note that these figures are for slightly out-of-date cameras, so the latest models should compare even more favourably.

Of course, these are only approximations and the images are straight out of the camera without any digital manipulation, but the argument about digital capture being 'nowhere near film' in terms of quality clearly doesn't have much substance in the light of these tests. In the case of D-SLRs with 11MP and more, the only superior medium appears to be 645 transparency and larger. Digital capture, however, is more than just a quality issue - the benefits to anyone's photography are numerous. One thing is sure, when you view your first decent digitally captured image on your workstation, you'll be convinced.

A practical example The limiting factor in reproducing a scanned film image beyond its default size is how much the grain detracts from the image detail. Digitally captured images, with low noise, should be more expandable than a film version. I first noticed this when using the 3.1MP Canon D30 on a dolphin calendar shoot.

To cut a long story short, the D30 saved the day when my other cameras had been damaged by salt water. I sent the corporate client some thumbnails via email and they chose the shot on page 20 as the cover image.

Thinking how small the D30 image looked on the CD among the drum scans (2160 pixels on the longest side, against a massive 5606 pixels), I decided to keep the client happy and send them anyway. After a month of waiting, a package arrived containing the proofs of the calendar, and there were the D30 dolphins on the cover, reproduced at A3 size. I could not believe my eves - it looked as clean as a whistle, while the drum scans (all shot on Provia 100F slide film pushed to 200) looked grainy in comparison. This confused me, as a 5606-pixel drum-scan image should just about make it to A3 in size, whereas my D30 image - at a much smaller 2160 pixels - had reproduced much more successfully. The answer was that pushing the film to ISO 200 had increased the visibility of the grain, and drum

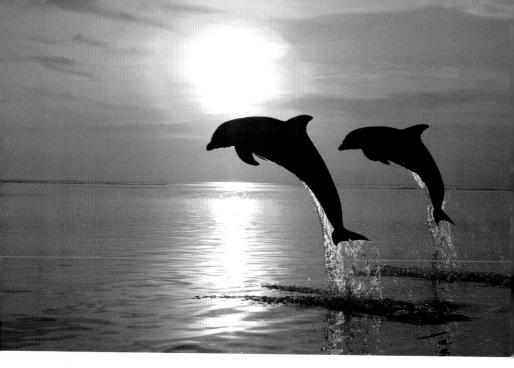

Above Although shot with a 3.1MP D-SLR, producing a frame just 2160 pixels on the longest side, the image retained enough quality for an A3 calendar.

scanning accentuated this even more. This experience, as well as many others, has led me to a controversial theory: it's my opinion that digitally captured images can be expanded to a much higher degree than scanned film images. The latter starts to exhibit displeasing grain soon after it reaches its maximum calculated size (although some grain-reducing tools can help to alleviate this), while the former does not

Conclusion Hopefully, this will have convinced most of you about the relative merits of digital capture compared to film. The main

problem now is one of technology. and the initial technical learning curve can seem daunting. In truth, it isn't; it's the confusing array of terminology and lack of clear information that makes this learning curve seem so steep. The rest of this book describes this technology and explains it in terms that anyone can understand. I'll cover all the aspects of digital capture, with useful tips and plenty of examples from my experiences as a professional photographer. I'll also identify some of the problems with D-SLRs and show you how to overcome them. Hopefully this will turn a steep climb into a gentle ascent.

INTERPOLATION: STRETCHING AN IMAGE

Ever looked at billboards and wondered what kind of camera was used to get such big images? Well, sometimes they are taken on huge 10 x 8in cameras, but most of the time they have been interpolated from 35mm images. Interpolation is the process of expanding the image by using complex software algorithms to work out how each pixel sits in relation to its neighbours. Extra pixels are then added to the image to enlarge it.

I am going to talk about interpolation programs a little later in the book, but the point I want to make at this stage is that digitally captured images can interpolate as well as – or even better than – their film counterparts.

My own experience with interpolation comes from a car dealership in Oxford, UK, which displayed three of my 13 x 9ft (4 x 2.5m) prints on the walls of their showroom. Two were made from D30-captured images (2160 pixels on the longest side), while the remaining one was a scanned 35mm film image. All three images were interpolated using a package called Extensis SmartScale, and standing underneath it's difficult to tell which one is the film image.

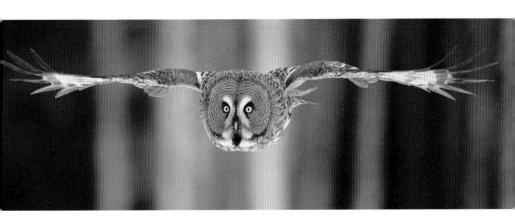

Above One of my favourite shots: a wild great grey owl gliding down onto its prey. Using the D-SLR screen I set my exposure so that it was correct before the owl took off, allowing me to concentrate on keeping it in focus as it swooped towards me.

Technical operation

At first glance the D-SLR may seem a little overwhelming from a technical point of view, and I had a very steep learning curve when I started using one. The purpose of this chapter is to introduce the technology to those photographers who are new to the world of digital capture. If you are already a D-SLR user, you may want to jump ahead to chapter 3, although some of the sections contained here

The easiest way to understand digital capture is to think of it as a workflow – a series of connected steps. This can be divided into four manageable chunks, and the diagram on page 24 shows all of the essential components. I've kept things simple to help anyone not at ease with digital technology. The starting point of the workflow is your picture idea, and the end point is your finished image, which is ready to print or send to a client or a friend

The D-SLR The D-SLR's role is to produce an image in your chosen format, then write it to digital film. There are two main formats for an image: RAW and JPEG. The one you choose is perhaps the most important decision you will ever make when using a D-SLR, and Chapter 3 will go into greater detail on the complexities of the RAW versus JPEG question (see pages 48-59). For now a RAW image can be thought of as an undeveloped film from the camera and a JPEG as a developed film ready for use. It is important to remember that although the choice of format can be changed on a 'per-shot' basis, once selected it is irreversible for the shot that you have just taken.

The download At some stage the digital film will either fill up or you will finish shooting. Either way it is time to download your images, store those you wish to keep and

clear the card for reuse. When at home, you are likely to download to a workstation; in the field it will usually be to a portable storage device. There are four main ways of downloading your digital film:

- direct camera connection to workstation via USB or Firewire cable
- place digital film in PCMCIA adaptor and insert into workstation (usually laptop)
- place digital film in separate hardware card reader, usually USB or Firewire connected to workstation
- 4) transfer images from the card to a portable storage device.

The relative merits of each approach will be found later in this chapter (see page 40).

Digital images can now be printed directly from camera providing that both the D-SLR and the printer in question are PictBridge compatible. While, the quality that you get from a direct print can be compromised, the immediacy of the operation can make it a useful tool.

The digital darkroom This is the workstation component (whether you use a PC or Mac), and can be

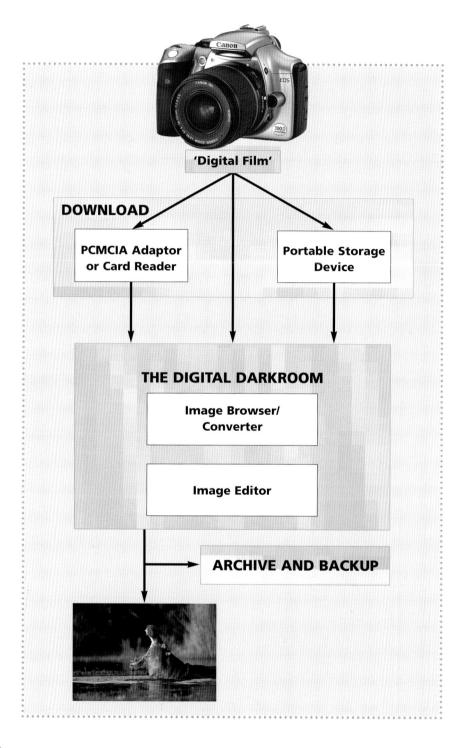

thought of as the developing stage. Using the range of tools available you can apply many techniques that were once restricted to the darkroom. Hence the term 'digital darkroom'.

One advantage of a D-SLR is that it costs nothing to take pictures after you have bought it. This means that you take more pictures than you did on film. So you must be more disciplined when editing your images. Later in this book I'll outline a simple hierarchy for ensuring that you only keep the best images, and with a minimum of time and fuss (see pages 105–6).

Archive and catalogue Digital capture is the world of the single-key delete (usually followed by a stream of expletives). Hard drives can and do fail, so having a good archive and backup solution is vital. This isn't as complex as it sounds, and several solutions also provide great ways of cataloguing your work (see page 130–3).

A technical overview

All D-SLRs perform differently, but internally they look much the same. The simplified diagram below is an illustration of a D-SLR's structure, and the next few pages present a brief guide to these components.

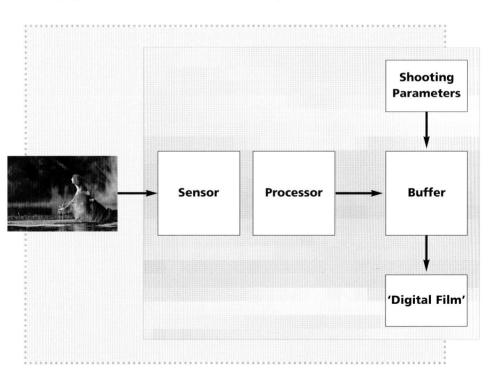

The sensor

As the hub of the D-SLR, the sensor's job is to interpret light falling onto it and turn it into the final image. I could spend several pages on sensor architecture and design but to be honest there is a not a lot that you actually need to know with regards to your photography. Broadly speaking sensors can be divided into three main categories: Bayer mosaic, Foveon and the Fuji's dual photodiode super-CCD. The diagrams opposite show how the architecture of all three compare:

- Bayer mosaic sensors: These
 use a single photodetector in a
 grid system, with each one
 seeing red, green or blue light.
 Complex software interpolates
 the value from each site, and
 its neighbours, to come up
 with an RGB value for that
 photodetector.
- 2) Foveon sensors: The Foveon system captures red, green and blue light at each single pixel site. Therefore the Foveon sensor has the potential to capture more colour and detail within an image than the Bayer mosaic sensor.
- 3) Fuji dual photodiode sensors:
 Similar to a standard Bayer
 mosaic; this sensor has
 effectively two photodetectors
 contained within a single

location. This sensor should have a greater dynamic range than a standard Bayer mosaic sensor, allowing a greater range between highlights and shadows.

Each sensor type has its merits, and arguments will always rage about which one is best. In reality, while it is useful to understand each type there is so much variety that you have to look at each sensor on a case by case basis.

Pixel size The type of sensor is not the only measure of image quality, the size of the pixel itself has an effect. Most D-SLRs have pixels that are 9 microns in size. with digital compacts being 4-5 microns in size. Smaller pixels of course allow more resolution but suffer from noise and sensitivity problems at low ISO ratings. Larger pixels have better noise and sensitivity performance, but offer less resolution than smaller ones. It is a balancing act between the two and some manufacturers are using 8-micron pixels to get the best of both worlds

Anti-shake sensor technology

Most of you will be used to having anti-shake technology on lenses from Canon, Nikon or Sigma. Some D-SLR sensors are now being developed with their own anti-shake technology, thus removing the need for this technology in

Bayer mosaic capture

Coloured filters are applied to a single layer of photodetectors in a tiled mosaic pattern.

Only one wavelength of light – red, green or blue – passes, and is recorded by any given pixel.

As a result, mosaic sensors capture only 25% of the red and blue light, and 50% of the green.

Foveon capture

A Foveon sensor features three separate layers of photodetectors embedded in silicon. Silicon absorbs different colours at varying depths, so each layer captures a different colour.

Foveon sensors capture red, green and blue light at every pixel location.

Fuji dual photodiode capture

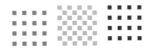

Fuji's dual photodiode sensor places 'light' and 'dark' diodes together. The information for one colour from those two photodiodes is combined.

Red, green and blue is captured separately with a wider dynamic range.

the lens. Konica Minolta have developed one such sensor and they claim that it can make the image as sharp as it would be shooting with three stops more shutter speed, which is great for shooting with long lenses or in low light conditions. This technology is in its infancy so you should check individual camera reviews to see how well it works

Below The diagram illustrates the impact of a cropped sensor, which increases a lens's effective focal length.

Sensor size

Each D-SLR's sensor is a subtly different size. However they can be placed in two groups, cropped and full-frame

The cropped sensor Most D-SLRs feature a sensor that is slightly smaller than a 35mm frame, as shown below. At first glance, it looks as if a D-SLR with such a sensor cannot produce images of the same quality as a 35mm full-frame image, but on page 18 I showed how it compared favourably with scanned film.

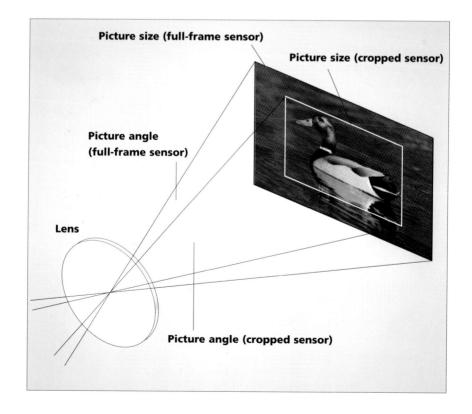

CROPPED SENSORS: LENS FOCAL LENGTH

Focal length with 35mm camera Focal length with APS-C cropped sensor

17–35mm	25–52mm
20mm	30mm
28mm	42mm
28-70mm	42-105mm
70–200mm	105–300mm
100mm macro	150mm macro
100-400mm	150-600mm
300mm	450mm
500mm	750mm

One of the effects of the cropped sensor is that the focal length of your lens is effectively multiplied. This an internal image crop, but the end result is that your lens becomes slightly longer. Most D-SLRs that fall into this category have a 1.5x effective focal length multiplier, the effect of which can be seen in the table above.

Many sports and wildlife photographers love this feature, as we get effectively a longer lens from our existing kit. For example, instead of adding a 1.4x teleconverter to my 500mm to make a 700mm f/5.6 lens, I can use the cropped sensor of the D-SLR to give me a 750mm f/4 lens – a longer lens that is one stop faster. Not only that, but in the case of a 300mm lens, this

produces a 450mm lens that can easily be hand-held.

Unfortunately there is a flip side. Landscape photographers suffer as a result of this effective increase. because a wideangle 28mm lens now becomes a 42mm lens. This is a major bone of contention with pros and amateurs alike. Achieving an effective 28mm lens requires the use of an 18mm lens, which may add distortion problems due to the super-wideangle effect. Taking pictures with 17mm or wider lens becomes even more of a problem. Nikon have addressed this issue with their D-SLR range by releasing the Nikkor 12-24mm DX lens, and other manufacturers have also followed suit.

The full-frame sensor These sensors have the same effect on focal length as a 35mm film SLR. But whilst the full-frame sensor delivers increased resolution (more pixels on a bigger grid), it has some inherent problems:

• Edge to edge sharpness – Most lenses are manufactured to have a slight curvature, with the sharpest point or 'sweet spot' in the centre where the lens is flattest. The outer edges are increasingly curved and the lens is at its worst quality next to the lens barrel. A full-frame sensor picks up these inadequacies and displays them as blurred areas at the extreme edges of the final image. A cropped sensor doesn't have the same limitation as it only uses the 'sweet spot' of the lens.

• High manufacturing costs – A full frame sensor costs disproportionately more money to manufacture than a cropped sensor. This makes D-SLRs with full-frame sensors more expensive than those with cropped sensors.

Moiré patterns and the anti-alias/low-pass filter These patterns are are caused by interference between the subject matter and the pixel grid. They are commonly seen as wavy lines and false colours, which occur when two conflicting patterns clash, as illustrated in the diagram, below. Most D-SLRs have an optical filter in

front of the sensor called the antialias or low-pass filter. This filter reduces the occurrence of moiré patterns by 'softening' the image data, which is one reason why D-SLR images often need sharpening to bring out their full detail. The strength of the filter is a trade-off, if the filter is too weak the images are prone to moiré but if it is too strong it may cause softening and loss of resolution. Pixel size also plays a part; smaller pixels in a larger grid enable the anti-alias filter to be reduced in strength, theoretically giving a sharper image. This is partly why manufacturers are starting to release D-SLRs with increased grid and decreased pixel sizes (my latest D-SLR has an 8 micron pixel size). Some manufacturers have released D-SLRs without anti-alias filters, claiming a sharper image. Whilst this is true, the moiré patterns can

Above The moiré effect is caused by the intereference of two pattterns.

make the images unworkable and personally I'd hate to have my sensor exposed to the dust of the outside world.

Sometimes moiré patterns appear in the finished image and they are very difficult to remove. There are some good, if complex, methods for this on the web as well as a few PhotoShop plug-ins.

Chromatic aberration This isn't specific to digital capture as it also occurs in film cameras. Chromatic aberration, 'ghosting' or colour fringing – illustrated in the extreme magnification above - usually appears as a red-green fringe around out of focus subjects. It is really a lens issue that normally occurs at extremes of aperture: unfortunately the nature of a D-SLR can enhance its effect. Some cameras customize their processing depending on the lens in use, so check that you have the right lens selected, and keep your firmware up to date. As a general rule the smaller the sensor size the greater the chance of chromatic aberration.

Sensor conclusions Clearly the subject of sensors is a complex one. For most photographers the choice of sensor is a non-issue, as they can't change the sensor that their D-SLR is supplied with. Also, some of the effects mentioned above can be very difficult to actually see, even for the trained eye. Therefore it's best not to get too stressed

Above Here chromatic aberration is visible in extreme magnification.

about it, just be aware of all the issues and don't base your buying decision on the sensor alone. One thing is sure though, manufacturers will continue to advance sensor technology, and the current trend is towards larger sensors with smaller pixels, to reduce the impact of the anomalies highlighted here.

There are a few ways of overcoming the problems of using wideangle lenses with full-frame sensors. You could crop the image's edges in the digital darkroom and then interpolate it, invest in a new digital-specification lens, or step back and use a longer focal length. Most experts agree that focal lengths greater than 24mm, make problems with blurred edges much less apparent.

.....The Bottom Line

FourThirds: An industry standard

Until recently, most camera manufacturers simply adapted their D-SLRs to fit their existing 35mm lenses, meaning that those of us with lenses of a single make are restricted to that manufacturer's D-SLR offering. Although competition is increasing there are only a few D-SLRs for owners of each particular lens series to choose between.

Kodak and Olympus have signed an agreement to implement a new open standard for digital cameras called FourThirds, and they have been joined by a number of other manufacturers such as Fuji and Sigma. Importantly, it allows a common lens-mount system. The main marketing angle is that the FourThirds system is the first to be designed solely for the needs of a digital photographer.

There are three issues that need to be considered for FourThirds. The first is that the widened lens mount means that you will have to start your lens collection from scratch. The second is that as things stand you may be restricted to using a Kodak sensor in your D-SLR (how this affects manufacturers like Fuji that have invested heavily in their own sensor technology remains to be seen). The final issue is where Foveon fits in, as they have a patent on their sensor and at this early stage their technology seems likely to become a major force in the

Above The Olympus E-System is based on the FourThirds Standard. All of the system's components and accessories have been designed specifically for digital use, and increased competition as other manufacturers produce their own purpose-built digital solutions should benefit D-SLR users.

market. Time will tell on all of these issues, but the principles and ideology behind FourThirds should be applauded, as competition is great for photographers. Also, one benefit of lenses designed specifically for use with D-SLRs is that they are smaller and lighter than existing film-camera lenses.

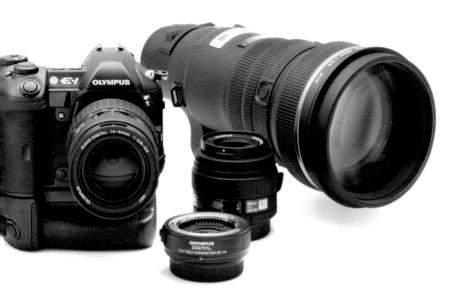

Digital-specification lenses

Several manufacturers have released new 'digital-specification' lenses that have been specifically designed for the needs of D-SLRs. They are normally denoted by a 'D' somewhere in the lens's name, such as Nikon's DX series. In basic terms. they all address the issues caused by digital sensors by having flatter lens elements, higher-specification manufacturing of the glass and often more multi-coatings to reduce flare and ghosting. These lenses can be divided into two types: those that have a full image circle and can still be used with film SLRs, and those that produce a sub-35mm image circle and can only be used with the relevant digital SLRs.

Which type you choose will be determined by two factors: whether you intend to continue shooting film alongside digital, and the limitations of the lens manufacturer's range.

Below Digital-specification lenses such as Nikon's DX range address the optical problems of digital photography.

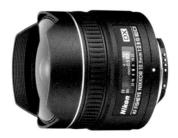

Buffer considerations When you press the shutter button, the D-SLR processes all of the data from its sensor grid to record an image. Writing this image to digital film is a slow process, and to protect the integrity of the stored images the D-SLR stops you taking any more shots during this period.

This is known as 'lockout'. If D-SLRs were designed in this way, the process would be take a shot and be locked out, take a shot and be locked out, and so on. Fortunately, D-SLR manufacturers all incorporate a temporary memory buffer. Writing to this is a lot guicker than writing to digital film, and so it minimizes the effects of lockout. The buffer holds a finite number of images and allows the photographer to keep shooting until it is full. At this point, or if the D-SLR detects that your picturetaking has finished, your images are written to digital film.

EL0125₅5.6 PSOAM PRIME [r6.0] \$

The number of images that the buffer can hold at one time is called the burst size or burst depth. The exact number of shots the buffer will hold depends on file sizes and types as well as other factors.

Many D-SLR users overlook the buffer, but knowing how the buffer works allows you to manage it better and helps to avoid missing pictures during lockout.

Different manufacturers have implemented their buffers in slightly different ways. Dual buffers, allow you to shoot continuously while the buffer gradually fills up with images until it reaches the maximum burst size. When this is reached the buffer is full. If the D-SLR detects that shooting has finished then the images are written to digital film. Up to this point this is the same as a single

Above and left Writing image data to the memory buffer is a lot quicker than writing to digital film, and so it reduces the effects of lockout. These examples of a D-SLR's displays show that the buffer has six shots remaining before it is full and lockout will occur.

buffer. However, with a dual-buffer system, if shooting continues the D-SLR processes the images in the buffer. This frees up space, which can be used to take more pictures. Of course, there is a limit, and when the buffer is totally full lockout will occur and all of the images are then processed, before being written to the digital film.

Using flash The one area of a D-SLR that does slightly lag behind a film camera is flash. The D-SLR sensor is so sensitive to light that it picks up flash like never before, which means most shots will end up chronically overexposed if left to technology alone. Some manufacturers have woken up to this and released digital specification flash units, whilst others are beginning to modify their D-SLR TTL-metering defaults (generally D-SLRs released after mid-2004).

Even if you are lucky enough to have one of the above, you'll sometimes get some overexposure. If you have an older D-SLR then you'll have no choice but to make some corrections. Here are some tips to make it easier:

 If you use fill-in flash then get your basic exposure right first without the flash switched on; this helps to balance the light.

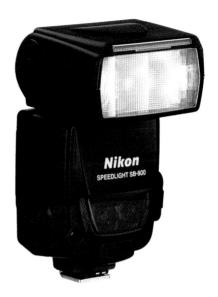

Above Dedicated flash units such as Nikon's SB-800 are designed to compensate for some of the exposure problems that can occur with D-SLRs.

- 2) Set the flash unit to a compensation of –2 stops and use the LCD histogram and highlight alert to check the results. If the exposure is too bright then compensate down.
- 3) A diffuser is a good accessory to use with a D-SLR and will help prevent overexposure.

One advantage of using flash with a D-SLR is that its range is often increased, which is useful for sports and wildlife photography. Just be careful and practice; soon you'll get good results.

LCD highlight alert A D-SLR is prone to burning out the highlights in an image, especially white subjects on a bright sunny day. Burnt highlights are bad news as they cannot be corrected at the post-processing stage because they simply have no detail recorded in them. Most LCD screens now have a highlight alert, which provides a graphic indication of any burnt out areas. This is usually in the form of 'marching ants' or 'zebras'. A quick check of the LCD can show you if this has happened; if it has then it's best to delete the image and use the exposure compensation to shoot the next image darker.

D-SLR feature summary All of us, whether experienced professionals or novice users picking up a D-SLR for the first time, have certain requirements. No camera will do everything that we want, so it's a question of compromise. As a professional you'll either need speed or the ultimate in quality and resolution. Professional cameras only cater for about 0.01% of D-SLR users, so what about the rest? The simple rule is to buy what you can afford, as there isn't much between the rest. The latest consumer D-SLRs offer cracking image quality, good performance, great prints at A4 and beyond, as well as being reasonably priced. D-SLRs at the lower end of the price range are also attractive if you are converting from one manufacturer to another, as they

Below The Canon EOS 300D/Digital Rebel broke the mold for D-SLRs offering a good resolution – 6.1 megapixels – and acceptably fast processing in a camera that didn't break the bank.

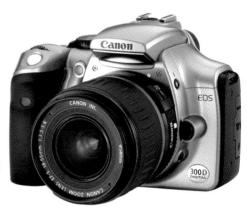

are often bundled with a lens or flash unit. Whichever system you choose, it is bound to be surrounded by a lot of hype and misinformation, so it pays to check out the reviews in photographic magazines and trusted internet review sites (see the Appendix on page 141 for details). At the end of the day the choice you make will probably be governed by your existing lenses (they will work on a D-SLR), but it might also be worth taking a look at what is on offer as this might be a good time to change your system anyway.

D-SLR-style cameras

One final point to note is the proliferation of D-SLR-style cameras. These are becoming more and more advanced and while their fixed zoom lens will never offer the same flexibility as a true interchangeablelens D-SLR system, they can still produce good results for their price.

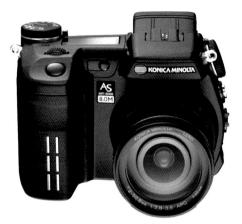

Below This image was shot using a consumer digital compact (the Canon G5), and shows superb quality even when enlarged to A4. I took it at a low angle by using the LCD screen to compose the picture.

Above D-SLR-style cameras such as Konica Minolta's DiMAGE A2 often feature a lot of advanced technology, and provide a halfway point between a full-blown D-SLR system and a 'point-and-shoot' digital compact.

Digital film

The small removable and reusable card that stores your images in a D-SLR is your digital film, the correct industry term for which is 'storage media'. Personally, I prefer the term 'storage card' and will use this from now on. There are many types of storage card, but at the moment the two most popular are CompactFlash (CF) cards and IBM Microdrives. The main difference is that the CF card has no moving parts, while the IBM Microdrive is, as its name suggests, a miniature hard drive.

The main advantage of the IBM Microdrive is that it offers the best megabyte value for money, as high-capacity CF cards are not cheap. The issues with IBM Microdrives are well documented and are summarized in the table opposite.

CF cards have few of these disadvantages. The solid-state design means that the temperature (both operating and generated), power usage and shockproof issues are much less of a problem than with IBM Microdrives. The main

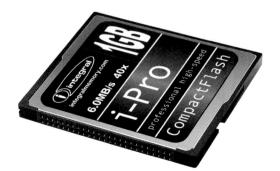

PRO TIP

It's no problem to use a larger capacity card, you just have to ensure that you download all images to a workstation / portable downloader when you have finished shooting. Waiting for the card to fill up is a dangerous game as accidents can happen.

issue with CF cards is one of price – per megabyte they are much more expensive than Microdrives.

Speed is also a vital issue. The quicker data can be written from the buffer to the storage card, the fewer lockouts occur. CF cards have always been slightly faster than IBM Microdrives, and most CF manufacturers offer 'ultra-fast' versions of their cards. Predictably, these are more expensive, and unless you are someone who really needs high throughput, a cheaper alternative will suit you just as well. Several well-known Internet review sites have compared transfer rates and have shown that some CF cards are faster than the IBM Microdrive, although some are much slower.

Left My chosen type of storage is CompactFlash cards, and extremely high capacity cards are available – at a cost.

MICRODRIVE PROBLEMS Excessive heat generation

All hard drives get hot, and the Microdrive is no exception. As it is located next to some heat-sensitive components – in particular the sensor – some manufacturers recommend against using a Microdrive in their D-SLRs.

Fragile technology

The Microdrive comprises moving parts, and can be susceptible to damage from shock.

Low operating temperature range

The specifications for the Microdrive put its operating temperature range from 0 to 65°C. This is great for sun worshippers, but not so good for the thermal-underwear brigade. I know for a fact that at low temperatures the Microdrive can become unreliable – while working in Finland mine often 'froze' and stopped working at temperatures below –10°C. Conversely, I used it in –40°C on top of the Rockies and it performed perfectly.

Greater power usage

The power consumption of a Microdrive is not negligible, and most experts believe it drains a D-SLR battery quicker than its counterparts.

Dual-format D-SLRs Some D-SLRS are now supplied with two card slots – one for the standard CF card and one for an SD card. The SD card is rapidly making inroads into the market as it is approximately one third the size of a CF card yet with a capacity of up to 1GB. The advantage to the photographer is obvious for these cameras, having effectively double the amount of card space before needing to download.

Summary The minimum card size that you should choose is 1GB for JPEGs and 2GB for RAW. This will ensure that you can shoot a reasonable number of images before filling up the card. Most manufacturers make claims about the speed of their cards which is usually stated in Mb/sec. This speed is often misleading as the D-SLR buffer cannot operate at these speeds, hence reliability is usually the key. One word of warning; when buying a large capacity card check first that your D-SLR supports their FAT32 disk requirements some do not.

Downloading images

Getting the images from your storage card onto your workstation is called the download stage. The main ways of achieving this, and pros and cons of each method are shown in the table.

As you can see, the cheapest and simplest solution is to connect the camera directly to the workstation via the supplied USB or Firewire cable. Using a portable downloading device is my preferred method of download, but look at the table below – it will help you to make the right decision.

PRO TIP

Look after your cards. Use a memory-card wallet to protect them from dust, and for peace of mind always keep one stored in the camera. I have actually walked out the door, got to a shoot and realized that my card was still in the card reader attached to my workstation. Don't make this mistake.

TABLE

6

DOWNLOAD CONNECTIONS

CONNECTION METHOD Direct camera to workstation connection	ADVANTAGES No extra cost, simple, fast	DISADVANTAGES Potential for expensive camera repairs as a result of excessive wear of components
PCMCIA adaptor	Small, portable, no camera connection	Extra cost, slow, mostly only for laptops
Hardware card reader	Speed – the fastest of the bunch	Extra cost (although this is not substantial)
Portable downloader	Speed – generally USB 2.0, portability, vital for travel	Expensive

Workstation choice: Mac versus PC

In the same vein that the choice between film and digital have caused controversy, so too does the guestion of Mac versus PC. It is certainly true that Macs were the machines of choice for the graphics industry, as they had everything a designer could ever want: systemintegrated colour management, high system RAM and fast processor speeds. PCs were always seen as tools for the office worker and. more latterly, computer-game players. More recently, PCs have finally caught up with their Mac counterparts and offer identical functionality and peripherals. Macs also seem to be climbing in price and shrinking in functionality, while PCs are getting better specified at a budget. Microsoft XP offers some levels of integrated colour management and there are now plenty of PC-compatible tools and devices to help with this. To be honest, it doesn't matter which system you use; it is what you put inside it that counts. For the record I use a Dell Dual Xeon Processor PC Workstation and have never felt the need to use a Mac.

Minimum specifications In much the same way as your choice of D-SLR is probably already governed by existing lenses, your choice of workstation may have been made already. Most of you will have a workstation of one form or another, and it is probably fair to say that most of you will have a PC. The more dedicated among you will have a stand-alone workstation that is used solely for graphics, with a separate PC for the Internet, home accounts and so on. I have such a system, but suspect it may be a little over the top for an average D-SLR photographer.

Before I frighten away computer novices, let me assure you that most modern PCs (those made since 2000) and Macs (of any age) will be perfectly sufficient for your digital photography. This area in particular suffers from jargon overload, so the following section outlines some minimum requirements to provide a good-standard workstation for digital imaging. This solid foundation can then be built on as your digital photography grows. Technology is advancing at such a pace that, by the time you read this book, things are likely to have moved on from the time of writing. But the information contained here is as up-to-date as it possibly can be.

Use a PC with a minimum Pentium III or AMD Athlon XP, or a Mac that was made after the mid-1990s and is not falling apart.

.....The Bottom Line

Processor speed No prizes for guessing, but the faster your workstation the better. If you are using RAW files, you'll be doing a lot of intensive processing work. Any workstation made in the last five years will probably do, but those made within the last 12 months will be much faster.

Top of the tree (at the moment) are Mac G5 dual processors and PC Xeon dual processors. These are both really fast and are used for movie editing. Having dual processors means that the workload is spread between the two CPUs, which in turn produces vastly increased throughput.

The downside is – as ever – the extra cost. PC users have the choice of either AMD Athlon or Intel Pentium/Xeon processors, and to be honest it doesn't make much difference. Speed, however, does, so try to buy a PC with greater than 1GHz. Anything in the iMac series will be great, as will any G4 or G5 (and even the old G3s).

For those of you with existing workstations that are below this specification, it may be possible to upgrade your processor card to a newer (and faster) model. The best bet is to speak to your manufacturer about this and not just buy something on the Internet.

RAM Random access memory (RAM) is a key requirement for image editing. The more you buy, the faster your workstation can

Have a minimum of 128 MB RAM and 4MB Video RAM for use with a 6.3 MegaPixel camera; more if you can afford it.

.....The Bottom Line

process graphics. For example, as a rule of thumb Adobe PhotoShop requires RAM of four to five times the size of the file that is being edited. For my EOS 1Ds, which generates a file size of 31MB, this means approximately 130MB of RAM. As D-SLR file sizes are increasing with each new model, it is better to buy something that is too big now and grow into it. If you have an existing workstation, installing new RAM – assuming that you have the capability – is easy.

It is also worth remembering that even though you may be shooting predominantly JPEGs, there will be times when you use the RAW + JPEG option (see page 59). This means that the minimum you should run with for a 6.3 MegaPixel D-SLR is about 128MB or, even better, 256MB (if you can afford it and have the slot space). For a fullframe D-SLR, a minimum of 512MB is needed to ensure that most of your time is spent working productively. Otherwise you might find that you spend time waiting for the workstation to catch up. Video RAM also plays an important

part, as this governs the speed at which images are displayed on your monitor. Most graphics cards now have a standard 4MB or more, which is more than sufficient for any digital photographer's needs.

Hard-drive space This is becoming less of an issue these days, as most new workstations are supplied with in excess of 40GB. Of course, your imaging and system programs take up quite a chunk, as will your finished data. The average 6.3 MegaPixel D-SLR converted RAW is approximately 18MB in size, which means 100 files take up 1.8GB. At this rate, if you are not disciplined your images can quickly consume all of your hard-drive space.

The storage requirement of JPEGs is much less, but there will still come a time when your workstation runs out of space. This will also affect applications like PhotoShop, which use spare hard-drive space as extra RAM. This is called a 'scratch disk', and it plays a major role in the speed of your system, so it pays to allocate enough space to one.

Right External hard drives offer a simple and flexible option for expanding your hard-disk space, as well as providing a good backup and archiving solution (see pages 130–1).

Have one dedicated disk as a scratch disk (minimum size 20GB) or get a separate external drive.

.....The Bottom Line

If you are ordering a new workstation, make sure that it has two internal hard drives. The primary drive, used for programs, data and so on, should be a minimum of 800GB, with the secondary drive around 20GB. This secondary drive can be allocated as the scratch disk and used solely for this purpose, ensuring that the system is really fast. Also, drives now come in various speeds, from 5400rpm upwards. If you want the

quickest system, it is worth paying the extra cash for the fastest. If not, 5400rpm will still suffice.

To modify an existing workstation, there are two options: partition the drive, or use an external hard drive. Disk partitioning allows you to form two smaller disks from your existing hard drive. But be warned: this is not a two-minute 'no-brainer', it is a complex job requiring a complete system backup and reinstallation, and so is best planned well in advance. My advice is to steer clear of this option.

The second option - an external hard-drive - is my recommendation because it gives many archive and backup options. Of course, this assumes that you have a Firewire/USB connection on your workstation. If not, a more complex SCSI drive may be your only option. These drives are available in sizes up to 500GB, with speeds matching that of internal drives, and are simple to install. I have six external Firewire drives and connect them when needed, although most of the time they are stored well away from any dust.

Peripheral connections The D-SLR and its associated hardware (external card readers, portable storage devices and so on) use one of two connection types to hook up to your workstation. The most common is USB (the latest is version 2.0), but perhaps the easiest to manage is Firewire (referred to as IEEE394). To use these connections you will need the necessary boards on your workstation. Macs have had these connections for some years, but older PCs may not. Ideally you want at least one of each, and further expansion can be achieved by using an external hub.

Operating system It doesn't really matter which operating system you use with a Mac, since all are designed to deal with graphics. I have heard multiple grumbles about OSX not looking the part, which is probably a reference to its similarity to Windows, but it does a great job with graphics. PC operating systems have a few more limitations, and I would say that Windows XP is the package of choice at the moment. It has some

You need at least one USB and one Firewire connection.
.....The Bottom Line

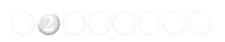

colour management built into the architecture and seems to be the most stable release since Windows 98. Be warned, however, that upgrading PC operating systems is a minefield and should be avoided if at all possible. Most PCs are designed to work with a single operating system as supplied, and any change voids the warranty and all support from the vendor (something that I found out the hard way).

Monitor Often ignored, the monitor is a vital component of the editing process. Without a good, high-resolution monitor you will not be able to inspect your images in sufficient detail, and your colour management will be suspect. The industry-standard monitors for editing are based on Mitsubishi

Below Peripheral connections are vital in order to connect the D-SLR and its associated hardware to your workstation. The most common connections are Firewire and USB ports. Diamondtron and Sony Trinitron architecture, and are designed for graphics. They come in a variety of sizes – 17in (43cm), 19in (48cm) and 21in (53cm) – but the larger versions are heavy and need solid support. Luse a Lacie 22in (55cm) ElectronBlue, which, though expensive, allows me to see very fine detail and make a judgement between two seemingly identical images. It also gives me extra USB ports (on the back of the monitor), which can be a bonus if you are lacking in that department. However, I am a specialist, and most users should be able to make do with the monitor that was supplied with the workstation. Those who want to upgrade, or are buying a new system, should consider either a 17in (43cm) Tron monitor or a high-quality flat-screen LCD.

I touched on the issue of colour management in the text above. If you want to colour manage your system so that you can achieve consistent results on your printer and to allow distribution to other workstations, you will need to use

either a software or hardware calibrator. These products require your monitor to be adjustable in terms of its brightness, contrast and individual red, green and blue colours. Without this you cannot calibrate effectively, and it pays to ensure that your chosen monitor can do this up front before you spend your hard-earned money on something that only does half the job. Don't worry if you already have a monitor that cannot do this, you'll just need to buy some extra printer paper and invest time in figuring out how your system behaves.

CD/DVD Probably the most common method of backing up and distributing images is to use a CD or DVD burner. Most new workstations are supplied with a CD burner and many have the option to upgrade to a DVD burner. Don't worry if your workstation doesn't have either as both are also available as external drives, usually connected via USB 2.0.

The difference between the two formats is really one of capacity; CDs store a maximum of 700MR of data whilst a DVD stores up to 4.7GB of data. For a large scale backup the DVD is clearly the winner and is more cost effective, but that is not the whole story. A single corruption on a DVD will lose a lot more images than one on a CD and although this is rare, it does happen. Therefore you should consider all the options carefully before deciding. I use a DVD burner for most of my backup work, only using CDs when I have a small amount of data to backup.

Above CDs are ideal for image archiving and distribution, offering around 700MB of storage.

Get at least a 17in monitor, ideally Diamondtron or Trinitron and with adjustable RGB settings if possible.
.....The Bottom Line

A CD-RW with a write speed of 24x is essential.

.....The Bottom Line

External devices I've already covered external Firewire hard drives, but another common consideration is a graphics tablet. These provide a position-sensitive pen (and sometimes a mouse), which allows you to be a lot more accurate with any digital manipulation. I use a combination of both, but prefer the mouse for most of the imaging that I perform.

Archive and catalogue

The first task that I perform in my workflow is to backup my RAW files, and the last is to backup the finished TIFF files. Storing images on hard drive only is a risk.

I have been caught out several times by a hard-drive failure and it takes a long time to recreate the files. The minimum requirement for a backup strategy is a CD-RW, but other devices can play a part too. A complete run down of all your options for back-up and, just as importantly, cataloguing, plus some suggested management strategies and products can be found on pages 130–3.

PRO TIP

There are several formats of DVD available, which include DVD-R, DVD+R, DVD-RAM and DVD-RW. For most applications either DVD-R or DVD+R (my choice) are all you will need but it's best to ensure that your chosen burner can manage all of the formats before you buy it.

Right If your workstation doesn't have its own CD-RW, an external CD drive is an important buy.

Choosing RAW or JPEG

I stand by my earlier claims: deciding whether to use
RAW or JPEG as your storage format is the most important
decision you will make when configuring your D-SLR

Most users I have spoken to believe that RAW is simply much better quality than JPEG. I was in this camp too, but now I'm sitting firmly on the fence. Both have their uses; the trick is knowing which to use, and when. I should say that there is a third format available on some D-SLRs, TIFF. This should be avoided (see page 63) so we'll concentrate on RAW and JPEG here.

An analogy

Before we look at RAWs and JPEGs in detail, their different workflows need to be defined. A useful analogy is to think of the RAW versus JPEG question as washing the car. For those of us without much time, the automated car wash is a useful tool, once you put your money in the slot you can sit back as the brushes scratch at your paintwork. In five minutes you have a relatively clean car. It's not perfect on close inspection, but good enough for what most people need. The problem is that once you've selected your program it is impossible to change it, and the only alternative is to go though the whole cycle again.

Think of the JPEG workflow (below) as the automated car wash. It is quick, requires minimum effort, and produces very good results.

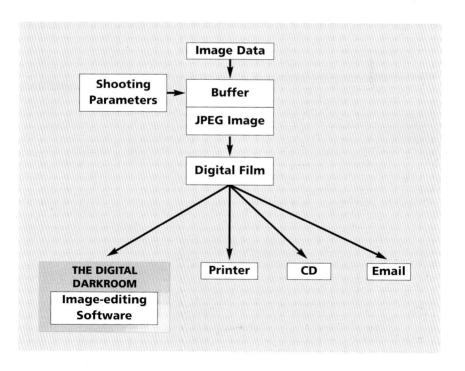

The JPEG itself can be thought of as a digital slide – once you press the shutter button, the image is 'developed' and ready to be used straight away.

The RAW workflow (below) is more like choosing to wash your car yourself. You do so in a set pattern – first you wash, then rinse, dry, polish and finally wax. You don't wax before you wash and don't polish before you dry. Doing it

yourself is a pride thing. You pay attention to detail, and produce a much higher quality result. If you get something wrong you go back and redo it. The problem is that it takes a lot of time.

Within the D-SLR the RAW image data is acquired from the sensor and loaded into the buffer, along with user-specified shooting parameters. These parameters can be customized via the LCD menus

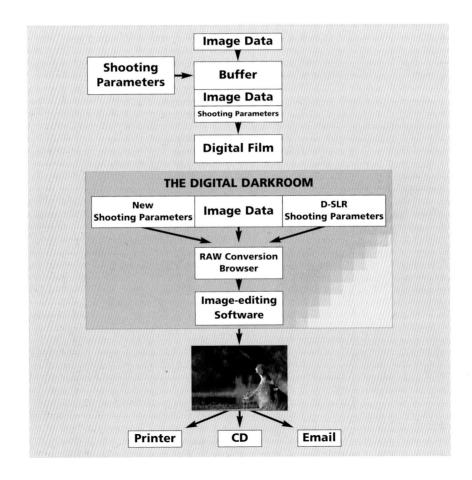

and allow you to specify values for sharpness, contrast, saturation and white balance (among others) on a per-shot basis, (see pages 61–5)

If JPEG is the required format. these shooting parameters are applied to the RAW image data. which is compressed into JPEG format. Finally, the JPEG is written to the storage card, and at this point it is finished and ready for use. It can be loaded into PhotoShop for slight tweaking, or immediately printed, emailed or burnt to CD. I know several pros who simply download their JPEGs straight to a CD burner and hand the finished CD to the client - no. processing, no hanging around at labs, no scanning. It's just the same as the automated car wash - no hanging around or hard graft. The problem is that the shooting parameters, once applied, cannot be changed. Although an image can be rescued in PhotoShop there is a limit to what can be done, and if you get the shooting parameters wrong you will have to start the whole picture-taking process again.

This approach, despite its drawbacks, appeals to many film users as it mirrors what they do now. Once you press the shutter you have the final image. The only difference is that a D-SLR can help you get the shot right first.

The RAW workflow can be thought of as the manual car wash. It takes longer, but is more flexible and the result is generally better.

The image data is loaded into the buffer as before, along with the shooting parameters. This time, however, unlike the JPEG workflow, the image data is not processed or 'developed' any further. The shooting parameters are not applied and are shipped out to digital film along with the image data. The difference at this stage between a 'developed' JPEG and a RAW file can be illustrated graphically (see page 52).

The JPEG on the left looks much sharper than the RAW on the right. but both of the images have the same shooting parameters and levels of sharpness. The difference is that they have already been applied to the JPEG at the D-SLR stage - it is a finished image. The shooting parameters for the RAW image are attached to it, but only applied at the browser stage. If you don't like the parameters that you have taken the shot with, they can be discarded and new ones used (except for ISO and exposure). This is the major 'architectural' difference between RAW and JPEG.

The pros and cons

Clearly there are differences between RAW and JPEG, but which is the best? The answer is that they are both useful. To demonstrate the pros and cons it is necessary to look at all of issues about their usage.

Quality As a RAW image is pure data, while a JPEG has been compressed, it would be natural to assume that RAW provides higher final image quality. The only way to verify this is to test it, which I did with the RAW + JPEG option of my EOS 1Ds. Using the face-painting image (below), I converted the RAW file into an RGB-TIFF file using the same shooting parameters as had

been applied to the JPEG. If you're wondering what an RGB-TIFF is, just consider it as the 'developed' form of a RAW file. At 100% they both look identical, so clearly a much higher magnification is needed (opposite).

There is surprisingly little difference between the JPEG and the TIFF versions, even at this high magnification. It follows that if you printed these two at the same print size, you'd notice little difference. However, there is a big difference in

Below A direct comparison between a 'developed' JPEG (left) and an 'undeveloped' RAW (right).

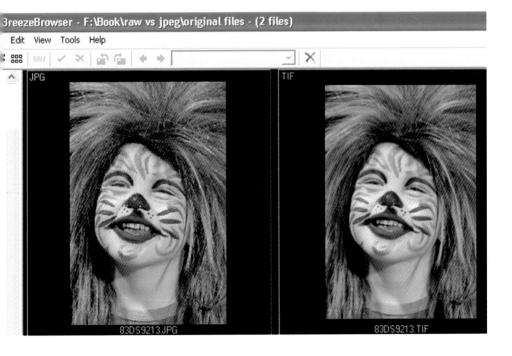

the file size. The TIFF image is 32MB, while the JPEG is around 5MB, a huge reduction in size without apparent loss in quality.

The compression capabilities of a JPEG have long been known, but all too often these have been associated with a drop-off in image quality. Modern JPEG algorithms, which are used in the latest D-SLRs, are highly efficient, and the key is how much lost information our eyes are able to resolve. At the highest quality settings it is now true to describe JPEG compression as 'visually lossless'.

The main problem with JPEGs is that they cannot be edited and continually re-saved without an appreciable loss in data. Each individual save compresses the data further, so even though the maximum-quality JPEG may be specified a small amount of image data is lost each time. For the following test I saved the same JPEG

file five times, each time using the highest quality setting (12) in PhotoShop.

The difference between the fifthsave file and the first is noticeable (see page 54), but perhaps not as much as would be expected. From a maths point of view these images are substantially different, but visually they are almost identical. Admittedly, if I had carried out lots of processing between saves, the differences would be more apparent. However, the question remains, 'how much we can perceive the changes visually?' If you intend to do some processing on your JPEG image then you can save it as a lossless RGB TIFF. This can be done either at the browser or PhotoShop stage. This approach is demonstrated in more detail later. in Chapter 7. The downside is still that you are lumbered with an 'outof-the-camera' image, without much flexibility.

Right When viewed in extreme detail, some differences become apparent between the two formats. However, the fractional drop in quality experienced with the JPEG belies its much smaller file size (5MB, compared to a massive 32MB for the RAW TIFF).

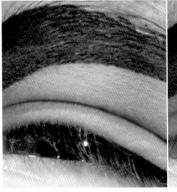

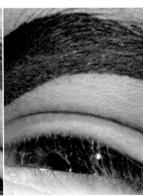

TIFF JPEG

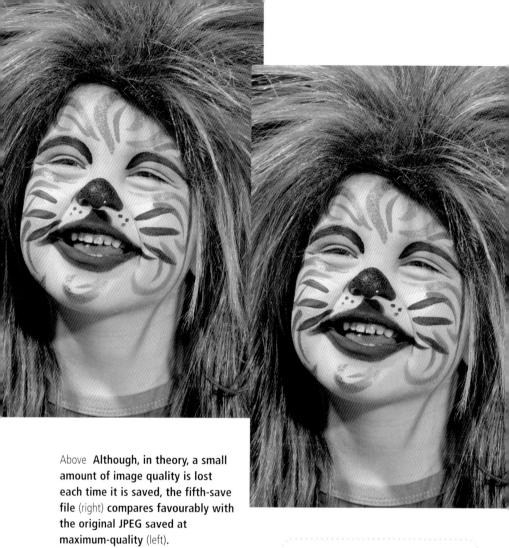

In terms of visual change there appears to be little difference between a 32MB TIFF and a 5MB JPEG that has been saved several times. If all you are doing is printing up to A4, no one will be able to tell the difference between the two.

.....The Bottom Line

Flexibility By now it should be apparent that the question of a difference in quality between RAW files and JPEGs is not so clear-cut. One issue that is without question. however, is that a RAW image allows a lot more flexibility at the 'developing' stage. If you get the exposure or white balance wrong with a JPEG, you can do little to change it. Of course, you could use an image-editing tool like PhotoShop to make adjustments, but this is time consuming and may not always produce great results. RAW images suffer from few of these limitations: as the shooting data is not applied to the RAW image data, it can be changed at the browser stage of the workflow. For example, if the image is slightly too dark, it can be brightened using the 'undeveloped' raw image data rather than the 'developed' image data.

Personally, in my field of wildlife photography I am constantly dealing with the vagaries of light conditions and different shades of fur, which play havoc with my metering. I shoot RAW by default and develop the files at the browser stage, which allows me to have maximum control of my images. The downside is that I normally have a stack of over 2,000 RAW images waiting to be processed, and if they are stuck on my PC they aren't earning me money. I know a lot of fellow pros who also shoot RAW to allow maximum flexibility, but all of

us suffer from the backlog that this can create. There are some tricks to speed up the RAW editing process and they will also be outlined in chapter 7 (see pages 116–21).

Noise Signal noise from an imaging sensor is more apparent with a JPEG than a RAW image due to the compression. In fact, there is no doubt that with long-exposure or low-contrast photography, RAW images do exhibit less signal noise than JPEG images. Whether this is detectable in every situation to the human eye is less certain, but for now I'll assume that it is.

If you are shooting long exposures (perhaps at night or inside a building), a RAW image will probably be your preferred choice. With this kind of landscape image it is extremely difficult to get the exposure exactly right, so some later processing will usually be necessary, reinforcing the need to use RAW.

.....The Bottom Line

Dynamic range RAW images, since they are formed directly from the sensor, have 12 bits/channel of data. JPEG images, due to the processing and compression within the D-SLR, are output at 8 bits/channel. A 12-bit image should have a greater range of colours than an 8-bit image, giving more scope to make changes. This means that a RAW should be dynamically superior to a JPEG, and having more

bits available also allows greater latitude for any subtle changes in colour.

Human eyes suffer from many limitations, and one of these is in their limited ability to perceive colour at the higher and lower ends of the spectrum. The 12 bits of colour contained in a RAW image may not actually be perceived as 12 bits at all, but slightly less. Couple this with the fact that to be

Below This atmospheric shot of a lion in the Masai Mara has been deliberately underexposed to create the effect. Moody images like this can often be prone to some signal noise (see page 55), but with careful processing in the digital darkroom its effect can be removed.

displayed these 12 bits have to be converted to 8 bits anyway, and the differences are virtually impossible for the human eye to detect.

Performance and storage considerations Any professional sports photographer worthy of the name will shoot JPEG. They do this for two reasons: image size and performance. Beaing able to fit more images onto a card means having to change cards less often, which reduces the chance of missing a great shot.

In terms of performance, consider the following test I carried out on the Canon EOS 10D.

I shot continuously until the buffer was full, then recorded the time that it took for the next shot to become available. For a RAW this was approximately 1.7 seconds, for a JPEG-FINE it was closer to one second. To write all the buffered RAW images to the storage card took nearly 40 seconds, while for the JPEG-FINE it took just over 12 seconds. Clearly, with JPEG-FINE the chance of lockout is drastically reduced, allowing more continuous action to be recorded. If action photography is your passion, JPEG-FINE should be the chosen format for this reason alone.

One last point on the performance issue: battery usage. Using JPEG gives a much greater number of shots per battery charge, as the D-SLR processing is less than for a RAW image. This may become

an issue if you are on holiday and don't have access to a regular power supply to recharge your batteries. The issues of battery usage and travel requirements will be covered on page 97.

TIPS FOR JPEGS:

- Shoot only JPEG-FINE, and set at the largest resolution.
- If you are going to print your image straight away, keep it in the JPEG format. If you need to save it once, do so at the maximum quality.
- If you are going to manipulate your image, save it first as a 'lossless' TIFF. Once you have finished all your manipulation, save it as a JPEG Maximum Quality.

Left To get this shot I had to lie underneath my vehicle, balance the lens on a beanbag and place a focusing point directly between the cheetah's eyes.

Software advances RAW conversion software is always being improved by manufacturers, which in turn can improve the quality of the developed RAW file. This means that you always have the option of improving your final quality by

using an updated browser, provided that the manufacturers do not change the format. (Which may happen if they adopt Adobe's new DNG protocol.) With a JPEG, you have no such option because it's already developed.

Summary Clearly there is not as much difference between RAW and JPEG files as might at first be thought. The main reason for shooting one or the other is the time factor. The JPEG workflow has the faster shoot-to-print time. Using the Polaroid-style exposure features on your D-SLR, you can ensure that vour JPEGs are close to the correct exposure. If you don't care about shoot-to-print time and want to have the ultimate flexibility manipulating images on your workstation, then RAW is the better option.

- If you aren't printing above A4, there will be little visual difference between RAW and JPEG-FINE.
- Although RAW offers the advantage of flexibility, it introduces post-processing time and reduces in-camera performance.
- Although JPEG has the shortest shoot-to-print time, it is a fully developed image and offers little room for manoeuvre outside PhotoShop.
- Photographers who use exposures greater than one second should use RAW to minimize noise and allow greater exposure flexibility at the developing stage.
- For high-action, news or PR photography, where high throughput is needed, JPEG should be the format of choice.
- For landscape and wildlife professionals, where clients demand ultimate image control (and in some

PRO TIP

A useful option on some D-SLRs is the RAW + JPEG option. This allows the D-SLR to shoot RAW and JPEG images at the same time. The JPEG has its shooting parameters applied, while the RAW has them attached but unapplied. This gives you the flexibility of a RAW with the convenience of a JPEG. Make sure that you set the JPEG option to its maximum quality, and be aware that you will fit fewer images on a storage card (approx. 25% less), have a reduced buffer, and longer write times. It's a useful option, and I know some pros who shoot RAW + JPEG so that they enjoy the JPEG's faster performance when editing.

cases are reluctant to move away from film), there is no choice but to shoot RAW.

• For the majority of D-SLR users, JPEG-FINE is the obvious choice. Provided that you adhere to the exposure guidelines, your images will be perfect for your needs, whether that means entering competitions, printing images to a reasonable size, or sending work to a camera magazine for publication (see page 134).

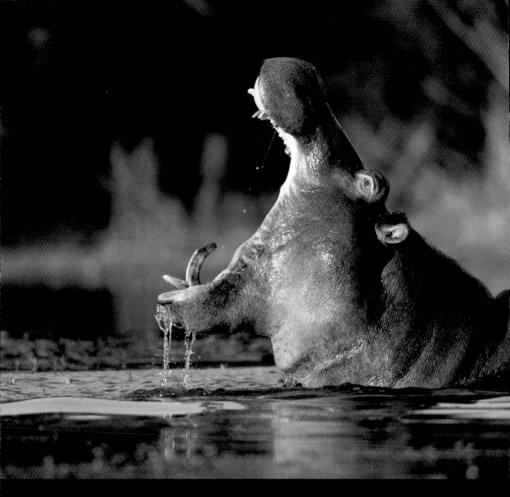

Setting up your D-SLR

Having covered the complex technical theory behind digital capture in the previous chapters, it is now time to look at how to set up the D-SLR ready for use in the field.

By now the concept of shooting parameters in a D-SLR should be pretty well defined. In the previous chapter, most of the arguments for the use of RAW files were based on the assumption that user-specified shooting parameters could be changed at a later stage. These shooting parameters come in several guises depending on the D-SLR you have; 'processing parameters' and 'user parameters' are just some of the names. For simplicity, we will stick with the term 'shooting parameters'.

The first fact to be aware of is that different manufacturers have different philosophies concerning shooting parameters, and you should check the default settings in your manual. Nikon took a handsoff approach with the D100, and by default most of the shooting parameters are initially switched off. This means that no sharpening is applied to JPEGs, and they may appear a little on the soft side. Canon, on the other hand, applied 'standard' values to their default setting, and as a result their default images look sharper, although this varies with each camera.

The idea of this chapter is to acquaint you with all the basic shooting parameters and their effect on an image. This is particularly important for JPEG shooters, as some parameters are irreversible. RAW shooters might argue that they do not matter at all because they can be changed at the

browser stage. While this is true for most of the parameters (except the ISO rating and certain exposure settings), it is surely better to get things right at the picture-taking stage rather than spending hours in front of your workstation.

The following are the most common parameters that you will find buried in your D-SLR menus:

- Image Quality
- Colour Temperature

 (on later models only)
- White Balance
- Colour Processing Parameters
- Colour Space/Colour Matrix
- Colour Mode
- Sharpening
- ISO and Noise Reduction
- File Numbering

Image quality

Although the previous chapter covered the issues of choosing RAW or JPEG, there are still a few more decisions to make with this parameter. Consider the table on page 62, which shows the options listed in a well-known D-SLR's manual (similar tables can be found in all D-SLR manuals).

If this seems like information overload, it is because there are just too many options available, most of which have no application or place in anyone's photography. The following headings take a detailed look at the more relevant options.

FILE TYPES AND SIZES

Format	Approx. file size	No. of image:	s
RAW	NEF (uncompressed)	9.4MB	54
	NEF (compressed)	5MB	102
RGB-TIFF	Large (3008 x 2000)	17.3MB	29
	Medium (2240 x 1488)	9.5MB	53
	Small (1504 x 1000)	4.3MB	119
JPEG FINE	Large (3008 x 2000)	2.9MB	176
	Medium (2240 x 1488)	1.6MB	320
	Small (1504 x 1000)	770KB	664
JPEG NORMAL	Large (3008 x 2000)	1.5MB	341
	Medium (2240 x 1488)	850KB	602
	Small (1504 x 1000)	410KB	1248
JPEG BASIC	Large (3008 x 2000)	770KB	664
	Medium (2240 x 1488)	440KB	1163
	Small (1504 x 1000)	220KB	2327

RAW Most D-SLRs just provide a single option for RAW, although they masquerade under a number of different names (RAW, CCD-RAW and NEF, for example). Nikon, however, allow you two RAW options: compressed NEF and uncompressed NEF. The initial assumption may be that compression means quality loss, but as mentioned in Chapter 3, this depends on how much visual loss is noticeable (see pages 52–3). The compressed NEF relies on the fact

the human eye can't visualize all the colours in a 12-bit uncompressed NEF, and effectively throws this 'blind' data away to achieve compression. (Check out the excellent D100 & D1 Generation eBook for more details.) My policy on shooting RAW is to select the maximum (uncompressed) size to capture the maximum amount of information. The file can always be cut down to size later, but you can't replace what you don't have in the first place.

RGB-TIFF RGB-TIFF is essentially the same as JPEG-FINE (i.e. a fully developed image). The only difference is that the TIFF is 'lossless'. This means that if you want to generate a lossless file for manipulation in PhotoShop, without any chance of preprocessing at the development stage (the browser) first, RGB-TIFF is the option for you. Of course, being lossless it can be tweaked in PhotoShop, but it is always better to tweak RAW image data than developed image data. This, coupled with a card-splitting file size of 17.3MB, makes RGB-TIFF a non-starter for most photographers.

JPEG How many JPEG options are there? How many do we need? The only JPEG options that are necessary are JPEG-FINE and JPEG-BASIC. The former is used for standard JPEG workflow processing and produces the highest-quality output. The latter will be used by professionals in conjunction with the RAW + JPEG option to generate tiny 'approval' thumbnails while working in the field. If you are shooting JPEG, my advice is to stick to JPEG-FINE.

Colour temperature

All sources of light contain varying amounts of the three primary colours: red, green and blue. The human eye perceives all colour sources to be normal – i.e. we don't see the different proportions of the primary colours in a certain light

source. Can you tell, for example, that a light bulb emits more red light than blue? No, because our eyes are marvellous tools that correct everything to look white. The colour of a light source is measured in units of degrees Kelvin (K), and this is referred to as its 'colour temperature'. The lower the colour temperature, the more red is contained in the light. Conversely, at the other end of the scale, higher colour temperatures radiate a higher proportion of blue light.

Photographers refer to images with a higher colour temperature as appearing 'cooler', and images with a lower colour temperature are said to be 'warmer'. Unfortunately, the camera is not good at adapting to different light sources, particularly artificial lighting. For example, using a daylight-balanced film (5,500K) indoors with tungsten lights will give an orange cast. This is because the tungsten lights have a colour temperature of around 3.000K, which is at the red end of the colour-temperature spectrum. To correct this and make the light source correspond to white (5,500K) we need to add blue – hence the use of a blue correcting filter with film cameras. The result is a balanced scene that matches what your eye sees.

Fortunately, the D-SLR provides several preset 'software filters' that allow you to cater for this very situation. This is referred to as the 'white balance' (WB). To put it

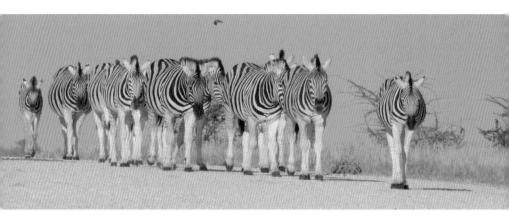

Above and below The image above has a blue appearance as the camera's WB was set to TUNGSTEN, but this can be corrected in the browser to produce the image below.

simply, with a quick adjustment you can now shoot confidently in any lighting situation and get a resulting image that looks 'normal' to your eyes. If you want to be creative, you can use the wrong white balance for any given situation, as shown above.

These images show the effect of setting the WB incorrectly for the ambient lighting. With the camera set to TUNGSTEN, the image takes on a bluer appearance (above). Inbrowser correction gives a more accurate result (below), but the arty side of me likes the original.

White balance

White Balance is a shooting parameter, and so the user must set it to an initial value. I say initial because as the light changes you can adjust the white balance accordingly to compensate, perhaps from sunny to cloudy. Most D-SLRs have the same subset of white balance settings, and those for the EOS 10D are shown in the table below.

It is pretty easy to select a WB that suits most conditions. Problems usually only occur indoors with different types of lights. Fortunately there are some options to help with this (see pages 69–70).

AUTO WHITE BALANCE (AWB)

If you are shooting RAW you can easily set the WB parameter to AUTO (or AWB). If the white balance is incorrect, you then have the option of changing it at the browser stage. When shooting JPEGs, it is vital that you assess the light conditions and set the correct white balance. Using AWB might seem the easy option, but there are many cases where AUTO is not the best choice and may give you misleading results. Again, the penalty for not getting it right when the shot is taken is time spent in front of the workstation making corrections.

TABLE			
	COLOUR TEMPERATURE PRESETS		
Symbol	Title and Description	Colour Temperature (K)	
AWB	Auto White Balance	3,000 - 7,000	
*	Daylight Sunny	5,200	
6 %.	Daylight Shade	7,000	
2	Daylight Cloudy or Hazy	6,000	
\$ wB	Flash	6,000	
\\\\\\\\\\\\\\\\\\\\\\\\\\\\\\\\\\\\\\	Indoor Fluorescent Light	4,000	
*	Indoor Tungsten Light Bulbs	3,200	
№⊿	Colour Temperature	2,800 - 10,000	
K	Custom White Balance	2,000 - 10,000	

A Guide to using white balance Perhaps the best way to show the effect of WB is to walk through several examples.

Example 1 Our first example shows Liberty, a bald eagle, shot in perfect late afternoon light at three different WB settings. The DAYLIGHT WB value shows a nice blue sky and perfectly balanced

colour on Liberty's feathers. WB SHADE in this case shows a much warmer cast, with WB AUTO warmer still. From the table on page 65, we can see that the colourtemperature setting for WB SHADE is 7,000K, which is much cooler than the actual light source (the sun) at 5.500K. With the WB set to record at 7,000K, the end result looks like an 81a warm-up filter has been placed over the lens. It's not a displeasing result; in fact, I prefer it to the WB AUTO setting, which is too warm, and the WB DAYLIGHT setting, which is slightly too cool. It's a personal preference and I know that my agent much preferred the WB DAYLIGHT results with the blue sky.

Left In this example of using the WB feature, the DAYLIGHT value (top) produces a nicely balanced result, while the SHADE (centre) and AUTO (bottom) settings give the image an increasingly warm cast.

PRO TIP

Using AUTO WB will often reduce or cancel the effect of a filter. Set the WB to DAYLIGHT for correct results. Of course, many photographers these days use tools like PhotoShop to apply filter effects to their images and have dispensed with real filters completely.

Example 2 A wildebeest is about to have a very bad day! This time the sun was low on the horizon and you can see that WB DAYLIGHT and WB AUTO gave the image the same 'cool' feel (around 4,500K). The problem is that the image was far from cool; the light was red and really beautiful. Setting WB to CLOUDY (6,000K) gives a much warmer image, but changing this to WB SHADE (7,000K) gives the most representative result. Again, WB AUTO was not the best choice.

Right WB settings: DAYLIGHT (top), AUTO (second top), CLOUDY (second bottom) and SHADE (bottom).

If you are shooting JPEGs then using WB bracketing is a good idea. The D-SLR takes a single exposure and processes it at different WBs. This will give you a range of images from which you can choose the best. This is of limited use when shooting RAWs as the WB can be altered at the browser stage.

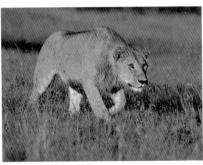

Above The combination of various forms of artificial lighting and diffused daylight, created an awkward exposure in which the digital camera's ability to alter the WB setting really comes into its own. The settings used are (clockwise from the top right): AUTO, DAYLIGHT, FLUORESCENT and TUNGSTEN. Of these, FLUORESCENT gives the most balanced result. By shooting RAW, it is only necessary to take one picture – the different WB settings can then be experimented with at the browser stage.

Example 3 When shooting indoors, the ability to change WB comes into its own. This example was shot for a magazine story on my local vet, Juliet Hayward. For more natural feel I decided not to use flash, but the mixture of ambient light sources created a problem. To solve this, I decided to use WB AUTO and select the best WB at the browser stage. With the WB set to DAYLIGHT the cast is slightly orange, but with WB TUNGSTEN it is far too blue. This suggests that the correct WB is closer to 5.200K than 3.200K, and means that WB FLUORESCENT (4,000K) gave the most balanced

results. Some browsers, also allow you to pick a custom white balance point from the image, which saves time (see page 70).

For those of you shooting JPEG, I have hopefully shown that WB AUTO is not always the best setting to use. In fact, in my experience WB SHADE gives much more pleasing results and the 'warmer' image that most of us like. If you're in an artificially lit situation, I recommend choosing RAW as it is more flexible.

Fine-tuning the white balance If you ever need a more precise WB value, most D-SLRs come with several parameters to fine-tune the WB:

- Colour Temperature
- WB Fine Adjustment
- Custom/Personal White Balance
- White Balance Bracketing

Colour temperature The most recent D-SLRs now have a colourtemperature (CT) parameter in addition to the WB, and this often causes some considerable confusion. The CT and WB parameters are mutually exclusive - you either use one or the other even though the menus seem to suggest that you use both at the same time. The idea of the CT parameter is to allow you to dial in a much more accurate colour temperature for the white balance. I know several professionals who have contracts in various theatres in London's West End. Each theatre has specific lighting requirements, but once a show is set up it doesn't change for years. So, at the start of the show's run, one of the pros goes along with a CT meter and measures the exact colour temperature at the venue. This information is then shared among the group of photographers, who use the CT parameter to enter it into their cameras.

To show how colour temperature can be used to change the overall balance of an image, I have re-used

Above The colour-temperature (CT) parameter offers another option to refine the white balance of an image. In this example, the WB has been adjusted to 4,500K (top), 6,500K (centre) and 8,500K (bottom). Of these, the first imparts a blue cast to the image, while the latter two are increasingly red.

The colour-temperature parameter is best left to those who really need it. For the rest, the standard WB settings are perfectly good enough as a starting point.

.....The Bottom Line

the image used in Example 1 (see page 66). As you can clearly see from the images shown on page 69. the lower, warmer colour temperature of 4,500K gives a blue cast to the image. While this certainly deepens the blue saturation of the sky, the problem with this approach is that it gives a blue cast to everything. The 6,500K and 8,500K images show increasing amounts of reddish cast, as you'd expect. Sometimes I do use this parameter but only at the RAW conversion stage in a browser to fine-tune the supplied WB settings.

WB fine-tuning Some D-SLRs allow you to fine-tune the preset WB colour temperature. This allows for minute variations in different light sources and is really for perfectionists. By far the most accurate readings in these situations are given by a colour-temperature meter, and not by fiddling with these parameters. My advice is to leave well alone unless you desperately need it.

Custom/personal white balance

There is a simpler way of adjusting the WB than carrying around a fragile colour-temperature meter. The terminology varies from one D-SLR to another, but most allow you to set a WB from either a stored image or a scene through the viewfinder. The most common approach is to hold up a white card in front of the camera, which sets

PRO TIP

Check your D-SLR manual to see where your WB sensor is situated. If it is externally mounted, watch where you place your fingers so that you do not obscure it.

the WB to correspond to white light. Again, this is a nice feature to have, but its application will be limited for most D-SLR users. If you are using the RAW workflow, most browsers will allow you to select a white-balance point from an image by using an eyedropper tool. I have used this approach only a handful of times, but each time it was necessary to save the image.

White balance: conclusion

If you are a JPEG shooter then you need to get the WB close to the optimum value for the light conditions to save lots of complex post processing. However, a RAW shooter can just set the WB to one of the presets and forget about it, as any corrections can be made when converting the RAW image. I shoot all the time with the D-SLR set to WB AUTO and correct at the digital darkroom stage as it saves less stress and hassle in the field.

Colour-processing parameters

Most D-SLRs allow you to set colourprocessing parameters such as hue. saturation and contrast. When shooting RAWs, these should be set at 'standard', and it's probably a safe bet to do the same with JPEGs. When you change the contrast of an image there is a fine line between a good result and a result that degrades an image's quality. This is easier to judge on a monitor than a D-SLR's LCD screen. Perhaps the most useful of these functions is saturation, which has applications across all areas of photography. Shooting at a high saturation will definitely improve the 'punch' of the image, although some subtleties may be lost in landscapes.

Colour space/matrix Colour management problems have been around for a long time. How many times have you printed an image on your home printer and wondered why it is so different from what you see on screen? The answer lies with colour profiles, or ICC (International Colour Convention) profiles, to be exact.

ICC profiles are universal colour standards. They are platform independent, meaning that an image with a given ICC profile should look the same anywhere (as long as the monitor is colour-calibrated). ICC profiles are vital to photographers for sharing images between devices, while maintaining

the intended colour. Once saved the profile is attached to your image and follows it wherever it goes.

Although there are many ICC profiles, there are two standard ones: Adobe 1998 and sRGB, Adobe 1998 has been accepted worldwide as the standard ICC profile for proofing images before they are used in the media. Most books recommend its use, and if you are submitting digital files to magazines they will require Adobe 1998 to be the attached profile. This is mainly because of its large colour range, which allows more latitude during the printing process, as well as allowing a smoother transition between colours in software like PhotoShop, sRGB has a smaller colour range than Adobe 1998, and as a result it is rarely used for media applications. One exception is the Internet, where sRGB is the recommended profile because of the relatively limited range of colours available on the web

sRGB may offer a better option than Adobe 1998, depending on the final destination of your work. Whichever you choose, make any conversions at the workstation stage and not within the D-SLR.

.....The Bottom Line

Left Three ICC profiles in print: Adobe 1998 (left), sRGB Portrait (centre) and sRGB High Chroma (right).

Most D-SLRs allow you to specify whether you would like Adobe 1998 or sRGB as your colour matrix/space. Some even offer other options, usually varying degrees of sRGB saturation. The images above show some variations.

The image with the Adobe 1998 profile (above left) has the widest colour range and technically the most accurate colour. To me, the sRGB options look much punchier and more marketable, even though they have fewer colours. The sRGB High Chroma version is perhaps a little over the top. It has very similar in output to Fuji Velvia, although the latter has a greater range of colours. Aesthetically, sRGB clearly has a lot more to offer than at first thought, and there is an even more compelling technical reason to consider it: most (if not all) sensors in D-SLRs are effectively sRGB. This means that they capture a range equivalent to sRGB and not Adobe 1998. Therefore, if you select Adobe 1998 the D-SLR processes the sRGB data internally to give Adobe 1998 data. This is standard in the graphics industry, and PhotoShop carries out the same profile conversion when you load images into it.

So what does this all mean? Well, it depends entirely on the intended destination of your pictures. If you are just taking pictures for prints, setting sRGB as your colour space/matrix is as good an option as Adobe 1998, Most PCs are sRGB based, and most printers default profiles are sRGB based too, so using this mode will get you reasonable printed results without the hassle of profiling. Moreover, a little experimentation never hurt anyone and you might find that you prefer sRGB. However, if you're reproducing in the commercial sector you have little choice, as the standard is Adobe 1998.

Colour mode Some D-SLRs offer a black & white mode. This might seem a good idea, but in reality it is not. Taking a picture in black & white is an irreversible process – once captured, you are stuck with that image data. Converting an image in PhotoShop will give you more control over the finished product, and it will look better as a result.

Sharpening D-SLRs usually provide a sharpening parameter, to control the level of sharpness attributed to an image when it leaves the camera. All D-SLR images need sharpening to some degree, but it must be applied correctly. It is important to realize that it can only make a good photograph better; it cannot make an out-of-focus image look sharp.

Over-sharpening an image can damage its appearance, and the image of an elephant hawk moth, below, shows how. The large version has maximum sharpening applied, and it shows in the top close-up. It is a sharp image, but any manipulation or interpolation will accentuate the sharpening objects beyond what is visually acceptable.

The bottom close-up has sharpening set to its lowest value. The image still shows good detail, but is not as well defined as the

Below The main shot and the top closeup have maximum sharpening applied. While the bottom close-up does not. Set your sharpening parameters to the minimum (or off, if possible) and apply sharpening later, either in the browser or using tools in programs such as PhotoShop. Unsharpened images also interpolate better.

.....The Bottom Line

heavily sharpened one. However, it is more flexible for manipulation, before applying sharpening later.

Sharpening can be changed at the browser stage in the RAW workflow, but not for JPEGs. Professionals shooting JPEGs prefer a sharper image out of the camera, as they do little processing before sending their images to clients.

I always set sharpening to the minimum. This lets me treat each shot individually. I recommend that you do the same as you can always sharpen in PhotoShop. It is best to sharpen images at the final workflow stage, as sharpening precludes further changes.

ISO and noise

The sensitivity of a D-SLR to light is similar to that of film. With the latter, as the ISO number decreases, so does the amount of grain in the image. A D-SLR is the same, except that film grain is replaced by signal noise. There are two main causes:

High-ISO noise The higher the ISO you select on a D-SLR, the more noise becomes apparent. Check out the examples shown opposite. The main image, and left close-up, was taken at ISO 100. The right close-up is from a similar image exposed at ISO 1600. The noise is obvious, especially in the darker areas of the fur. The ISO 100 image, on the other hand, is very clean. ISO levels between these ranges show varying levels of noise.

If you shoot an image at a high ISO and want to reduce the noise, you have a couple of options. First, RAW browsers often have excellent in-built noise reduction.

Alternatively, for JPEG images there are some PhotoShop plug-ins (see Appendix, page 141) that will give a similar result. The problem with all noise-reduction applications is they can remove image data by

Sometimes a little noise is no bad thing, especially in an image that is converted to black and white. There is no good substitute for the sensor generating high levels of noise and no amount of post-processing can reproduce the same effect. So if you

want a high-grain effect, just set the D-SLR to a high ISO value and the sensor will oblige!

A D-SLR can be used at lower ISO settings than a film camera to record the same detail because it is incredibly sensitive to light and picks up details that a film emulsion would miss. This may sound like a controversial theory, but it is one that I have developed through field experience. I first became aware of this on the dolphin shoot mentioned earlier in the book (see page 19–20). When one of the images was zoomed to 500%, I could see the outline of someone on a boat a couple of miles away!

I decided to put the theory to the test on a commissioned job at a cathedral. From a high vantage point in the rafters I set up my a D-SLR next to a film SLR with identical lenses. Then, during a candlelit procession, I took the shot

Avoid using ISO settings above ISO 400 unless you want noise in a picture. Personally, I never shoot above ISO 200 and rarely above ISO 100. If raising the ISO is the only option available to get the shot, be prepared to accept the consequences. At the end of the day, it's better to have a shot with some noise than no shot at all.

.....The Bottom Line

mistaking it for noise.

on page 74 with the D-SLR. The trails that you see are the choristers holding candles. The cathedral itself was in total darkness apart from the candlelight. The exposure was 30 seconds on ISO 200. The detail is phenomenal and while the film version picked out similar detail in the ceiling, at an exposure of about four minutes the people and the light trail were indistinct.

Using a low ISO is one way of reducing noise. If you limit yourself to ISO 200 or below then you will rarely see any noise. If you do find noise, there are some post-processing techniques that can be used to reduce its effect.

Long-exposure noise The most noise will appear in shots that are taken at night or of dark scenes. Long exposures allow the sensor to leak more signal data, which creates more noise. Note that this is a different kind of noise to the high-ISO variety, and it can have a more regular (and visible) pattern. There are four ways of reducing the effect of long-exposure noise:

1) Use a low ISO

Using a low ISO has already been covered, but by definition it means longer shutter speeds. It's a catch-22 situation – reducing the effect of high-ISO noise by using a low ISO lengthens the exposure, and increases the effect of long-exposure noise. Fortunately, this noise is only noticeable in exposures

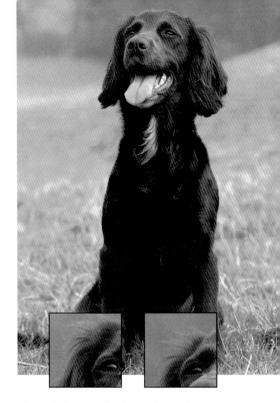

Above This example shows that noise can be created at high ISOs. The main image was shot at ISO 100, and a second at ISO 1600. The fall in quality from ISO 100 (above left) to ISO 1600 (above right) is clear to see.

of over one second. This style of photography tends to be planned for, so the methods to reduce longexposure noise as outlined below can be considered.

2) Avoid JPEGs

Avoiding JPEGs for long or high-ISO exposures helps reduce noise. Due to their compression characteristics, JPEG images can show more noise than their RAW counterparts, so for this application stick to RAWs.

3) Use in-camera noise-reduction

Using noise-reduction technology (NRT) sounds very grand, but it is simply a feature that helps reduce long-exposure noise. Some D-SLRs allow you to switch it on or off. while others just assume you want it. When used, the D-SLR takes two subsequent frames. The first is your image data; the second is a 'dark' frame. The in-camera processing then blends these images to remove any 'stuck pixels', producing an image with less noise. This is also the most compelling reason to use NRT, as the dark frame is only effective if taken at the same time as the normal frame.

Left Despite being shot in very lowlight, requiring a 30 second exposure, this image (taken on an EOS 1D) retains greater detail than a similar shot taken on my medium-format film camera. The ability of D-SLRs to capture fantastic detail at long exposures is one of the real benefits of using digital.

In-camera NRT has three main problems. First, the D-SLR makes a decision on which pixels in the image are noise and which are image data. Sometimes it can get this wrong and you can lose detail. Second, the two images are blended together in the buffer, which means that the space in the buffer is halved and the processing time increases accordingly. The buffersize decrease is not really a problem with this kind of photography, but the increased processing time can be. The final issue is that the internal NRT is irreversible, even for a RAW image, and once shot there is no going back.

Clearly there are pros and cons to in-camera NRT, and I prefer to turn it off and process the image later.

4) Maintain a low temperature Keeping the D-SLR cool reduces the noise in an image, as it is worsened by increased sensor temperatures. Therefore, set up your shot before switching on the D-SLR. If you can take your shot within the first few

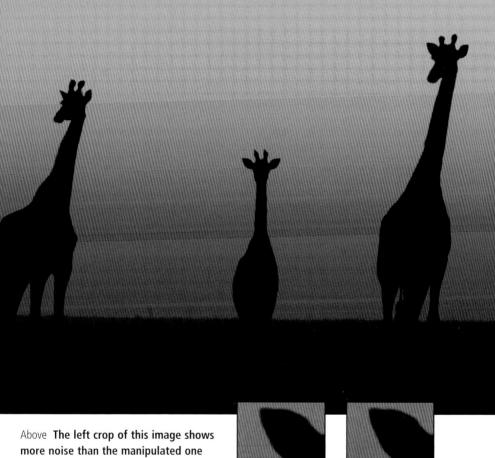

on the right. For me, the first captures the atmosphere of the occasion better.

minutes of switching on the D-SLR, the sensor will still be relatively cool and noise-free. Avoid using heatgenerating components like the LCD, and remember that using incamera NRT on several concurrent exposures will create heat, so don't expect the last image to be as noisefree as the first. Finally, in such situations a CF card is better than an IBM Microdrive as it generates less heat (see page 39).

Using noise Some images benefit from noise, as it adds mood and texture. Consider the example of the giraffes. The left close-up is a from the original, and shows noise, which is hardly surprising given the conditions. After processing the RAW image with my browser's NRT, the image looks cleaner (right closeup). However, I like the grainy feel as for me it adds to the mood of the image.

File numbering

Every time your D-SLR takes an image it assigns a number to it. This number is the file name that will be used on the workstation, D-SLRs have several different options for numbering, but they all work in roughly the same way. Some D-SLRs specifically designed for press usage, have a prefix that is unique to the camera: 83DS for my Canon EOS 1Ds, B63A for my Canon EOS 1D. This identifies the images as being from a unique camera, something that is important in the manic media world. For the rest. each number starts with a set prefix (DSC for Nikon, CRW for Canon RAW and DSCF for Fuji), then has a four-digit number between 0 and 9999. When this limit of 9999 is

PRO TIPS

Set your D-SLR numbering parameter to 'continuous' or whatever similar option is specified in your D-SLR manual.

Once at the re-numbering point, your D-SLR will not let you take any more shots until you verify that re-numbering is to take place.

reached the camera will reset to 0000 and therefore create a number for an image that already exists. This doesn't cause a problem for the files on the D-SLR, even if you leave them stored there for months on end, as they are contained in folders with unique names. Having separate folders is a good way to keep two sets of pictures apart. The main issue comes when you want to upload them to the workstation for processing. Sooner or later you will have a conflict between two images with the same name. Although 9999 seems like a high number it isn't because digital images are cost-free, you will find yourself taking large numbers of them

A good solution is as follows. First set up the D-SLR so that it continues the sequence number for the maximum time – so that it does not reset when a new storage card is loaded. Secondly, have a re-numbering policy on the workstation, which gives you more options. This along with other cataloguing issues will be discussed in more detail in Chapter 8 (see pages 126–37).

Opposite I love working with elephants; they never disappoint. I selected a focusing point at the centre of this one's forehead, switched the WB setting to SHADE to accentuate the colour and tested the exposure on the LCD screen.

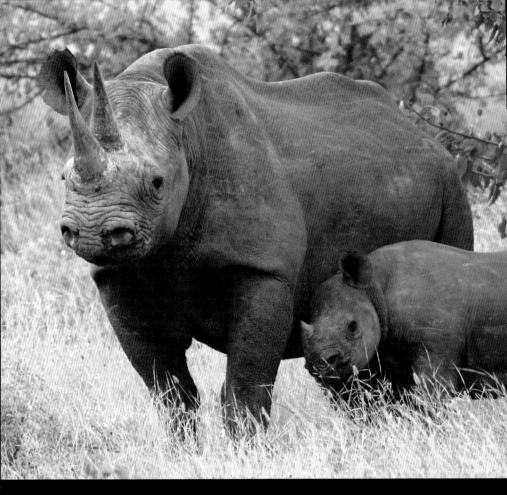

Field exposure guide

The previous two chapters have dealt with all the set-up issues of a D-SLR in great detail. Now it is time deal with the issues that are specific to using your D-SLR out in the field.

As discussed earlier, the common misconception that exposure is not important because a digital image can be corrected at a later stage is incorrect - image-processing programs can only do so much. Therefore, getting the exposure of your pictures right is equally as important with a D-SLR as with a film camera. With this in mind, the next couple of pages give a brief introduction to the subject of exposure in a way that aims to simplify a vastly over-complicated subject. This should provide a useful introduction to using your D-SLR effectively and achieving great shots.

Working with shutter speed

Shutter speed is a measure of the amount of time the shutter opens to allow the 'flow' of light onto the imaging sensor. Most cameras have shutter speeds ranging from 30 seconds to 1/4000sec. From an artistic point of view, shutter speed is used to control how you want to depict your subject if it is in motion. Practically, it is also used to minimize the chance of camera shake, which often ruins a potentially great shot.

Below This herd of Thomson's gazelles were fleeing from a cheetah, so instead of freezing their motion I decided to blur it and emphasize the action. I used a shutter speed of 1/30sec to achieve this, and panned the camera while the shutter was open.

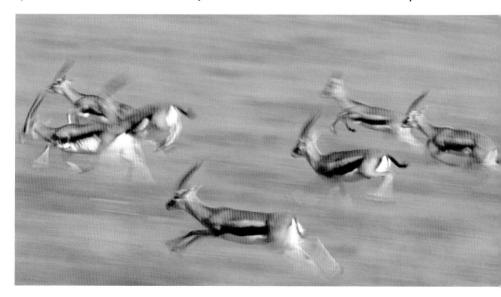

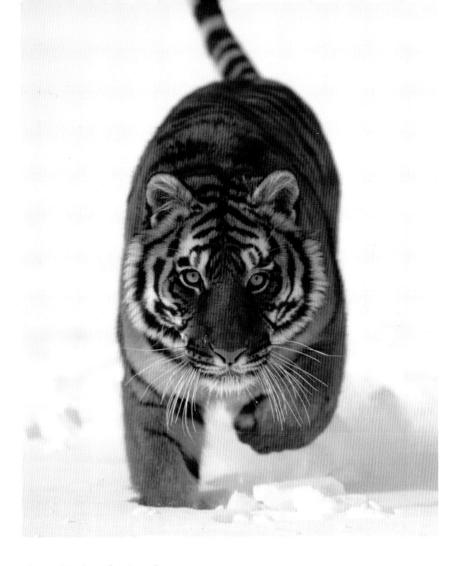

Above This shot of a tiger shows a different approach. Taken under controlled conditions, a shutter speed of 1/1000sec was used to freeze motion and help to create a more menacing atmosphere.

To create a blurred shot, use a shutter speed of below 1/60sec for most subjects. If you want to freeze motion, you'll need a much faster setting, usually 1/500sec or above.

.....The Bottom Line

Working with aperture

Aperture, measured in f-stops, is basically used to control the depth of field in an image. Most lenses have a minimum aperture of f/4, rising to a maximum of f/22-f/32.

To isolate your subject from the background, use an aperture of f/4–f/5.6. Apertures above f/22 should be sufficient for shots that require the largest possible area to be in focus.

.....The Bottom Line

Below left To isolate this hare from the background, I first selected a large aperture of f/4. However, using the depth-of-field preview function, I found that there was not enough depth of field to get both the ears and nose in focus. Therefore I selected a slightly higher aperture of f/5.6, which would still give great background isolation but retain more nose-to-ear detail.

Below right Landscape photographers often use small apertures to retain maximum depth-of-field. Here, faced with the enormous distance between the tree at the base of this Namibian sand dune and the summit, I selected an aperture of f/22.

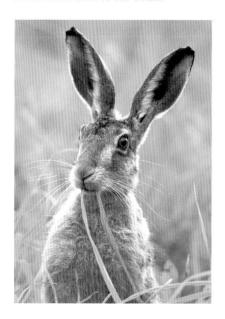

Exposure ratio Getting the correct exposure for a given situation involves a balancing act between aperture and shutter speed. Although there is only one correct exposure, there can be many combinations of shutter speed and aperture to give this value. For example, a combination of 1/125sec at f/8 is identical to a setting of 1/500sec at f/4, although the final results will be drastically different (because of the difference in depth of field and the effects of motion). This combination is known as the exposure ratio.

Program modes Most D-SLRs provide a number of modes that can help determine the exposure ratio. They range from fully automated modes, to those that require creative input from the photographer. While the former provide some useful functionality, it is the latter group on which I will base this chapter. More specifically, I will concentrate on two of these modes: aperture priority and manual modes.

A change in aperture requires a corresponding change in shutter speed to maintain the same exposure ratio, but this may not produce the effect that you want.

.....The Bottom Line

My wildlife photography has always been based on high-action one-off opportunities, and because of this I have refined my technique over time, leading me to forget all the other program modes and do everything that I need with just the aperture-priority and manual modes. Using aperture-priority mode I can control the aperture and consequently the shutter speed, to alter the finished image, in an effective and efficient way. Of course, I could do the same by switching to shutter-priority mode, but this takes time and requires me to take my eye from the viewfinder.

The light meter The problem with in-camera light meters is that the exposure they suggest often needs tweaking. Film users have grown accustomed to estimating how much exposure compensation is needed. Rules such as applying '- compensation' for dark subjects and '+ compensation' for light subjects have become the norm. However, there is plenty of guesswork involved.

PRO TIP

Learn how to move all your camera controls by touch alone, as you cannot take a shot if your eye is away from the viewfinder.

The D-SLR LCD

Unfortunately, D-SLR's light meters can still get things wrong. However, the D-SLR allows you to check out your image on the LCD screen. From this you can interpret how the meter is exposing the scene, and check the composition and so on.

The LCD has two tools to help you determine how your image looks. The first is the image review, which allows you to check out the composition, the effects of any filters used, or any other accessories. Using the LCD to view your images has a major drawback: it always shows every image as bright and happy. As a result, you cannot determine exposure with real accuracy. Fortunately, you can use

the LCD histogram – a graphic representation of an image's colour range – and, if interpreted correctly, can ensure consistent exposures.

When viewing a histogram, the horizontal axis indicates the brightness level, while the vertical axis shows the number of pixels recorded at that level. The left represents dark while the right represents light.

Below I used my D-SLR LCD to check the effect of the filters that I used for this exposure. Once I had the right combination, and the right framing, I transferred the filter rig to my Pentax 645 NII and recorded an identical shot.

Using the histogram Perhaps the biggest change to your photographic technique in the field with a D-SLR is remembering to use the histograms. It's so easy to fall into old technique and start banging away with an estimated exposure, then realize back in the digital darkroom that a histogram would have saved your images from being poorly exposed.

Tips from professional photographers are a great way to learn new techniques; not so much because of pros' ability but simply due to the fact that they know the quickest and best way to get consistently good results – our livelihoods depend on it. A couple of fellow pros at Wimbledon tennis championships told me that most of them spend several minutes before the start of a match taking test images and evaluating histograms. The white clothing worn during a tennis match causes real problems with exposure, especially in sunlight, and solutions for this are covered a little later in the book (see page 88).

One of my friends covered the last Olympic men's 100m sprint final, and spent a total of 20 minutes working with his histograms to get the exposure exactly right. In the ten or so seconds that the race took to complete, those 20 minutes would pay dividends - because he was shooting JPEGs he had no margin for error, especially because the images had to be on the way to his news desk within two minutes of the race finishing. This is a good philosophy to have, and where possible I always take at least one test shot to evaluate the histogram.

Evaluating histograms: Reality

Unfortunately, the histograms shown below have been created to illustrate a point, and rarely do I get anything like them in reality. The basic rule when interpreting histograms is always to strive to get a reasonable colour spread (covering at least two-thirds of the histogram) and with its average slightly to the left of the mid-tone point. This latter point is vital; shooting an overexposed image is a

waste of time, unless of course you intend to do so. Once an area in an image is overexposed, the detail is lost and no amount of clever digital-darkroom fiddling can replace it. However, shooting a slightly darkened image picks up extra detail, doesn't burn out the highlights and allows enough latitude for simple brightening in the browser or using PhotoShop. A dark image can easily be brightened up to one stop before losing any quality (more if the image will only be used to make a print). Also, an added bonus of shooting slightly darker is that you gain extra shutter speed.

Histograms come in all sorts of shapes, but as long as you apply the basic rules above you'll get the exposure that you want. The following pages show some variations of 'good' histograms.

Above At first glance this histogram appears too dark. However, the picture has lots of dark tones, which weights the pixels to the left of the histogram. In fact, the only 'bright' tone is the white flash on the horse's head. Given the situation, this is a perfectly good histogram and only needed slight brightening in the digital darkroom before being used on a calendar.

Left and opposite **These histograms show** medium tone (opposite far left), dark/underexposed (opposite left) and light/overexposed (left) exposures.

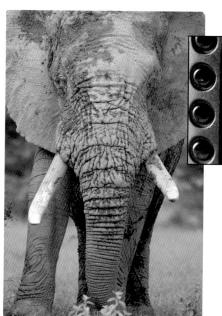

Above and left This is actually a pretty good result. The colours are evenly spread, with a bias to the dark side. This will produce a slight underexposure, which will retain more detail and increase saturation. As the subject, is dominated by shades of grey, this histogram is hardly surprising. I took the shot from a prone position, which caused the elephant much interest as it strode towards me.

Exposing for white D-SLRs tend to burn out highlights very easily. Hotspots of light coming through trees and white skies can cause real problems. Especially when subjects have white or bright colours in contrast with other areas of the image. The major problem in the shot of the bald eagle (opposite top) is the contrast between the white head and the dark body. To compensate, if you have white objects in your image, make sure that your histograms are biased towards the left-hand side.

Histograms in the field I always try to practise what I preach, so here's an example of a job for Le Chameau, an outdoor clothing specialist, where histograms saved the day. I was in the middle of a photo shoot, when I was asked to take something creative featuring a wellington boot! After several attempts I finally hit on an idea to have the boot in a small waterfall and blur the water around it. Normally I would have taken such a shot in overcast light, but the sun was high in the sky and we had a deadline. Once I'd picked the position and the subject was in place, I set up my camera. I chose to

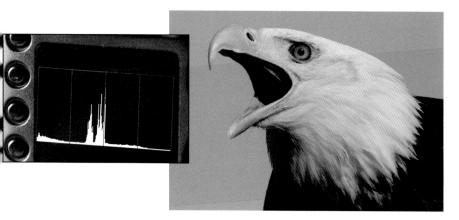

Above The histogram shows a very good colour range, although the average will be slightly on the dark side of medium tone. In fact, when taking the shot I compensated by minus two-thirds of a stop to make sure that the feathers did not burn out.

Below When using a long exposure to smooth the water behind the boot, I noticed that some highlights were burnt out (below left). The histogram confirmed this, so I compensated by -1 stop and tried again, (below right). The histogram was better, its average to the left of medium tone and the peaks on the far right were almost gone.

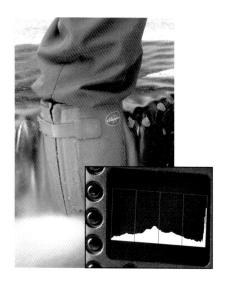

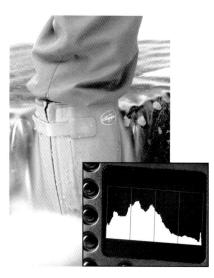

shoot RAW, as I knew the image would need to be post-processed, and the light was playing havoc with the WB and I wanted the option of changing it later.

I knew that in order to blur the water I would need the longest shutter speed available for the light, so I selected ISO 50 and the maximum aperture for the lens of f/32, a combination that would give me a slow enough speed to blur the water. Setting compensation to '0' I took my first exposure, covered my head with a towel and used the LCD to view the histogram. The results can be seen on the previous page.

Viewing histograms in the field

One of the major problems with histograms is simply seeing them. Even though LCD screens are bright, in direct sunlight they can be almost impossible to see. There are three solutions to this problem:

- Set LCD brightness to its maximum and view it in the shade.
- Use a special bellows hood over the LCD screen. I have used these several times in bright conditions and they work extremely well. Only attach them when you need to, as they can quickly get in the way.
- A delegate on one of my courses used a home-made solution instead: A toilet roll with a loop of string to hang around his neck. When viewing the LCD he placed one end against the screen. It may look stupid, but it is recyclable and available the world over!

Histograms - a Summary

- Look at the histogram first.
- Don't use the LCD picture display to assess exposure.
- Try to get the average distribution of the histogram to the left of the medium-tone line; remember that dark is good.
- Avoid peaks anywhere near the right-hand side of the histogram as overexposure can result.
- Assess the scene beforehand so that you are not taken by surprise.

Below Judging depth of field on the LCD has helped to get the subject sharp while blurring some background flowers. Photograph © T.J. Rich/ARWP Ltd

Hidden uses of the LCD The LCD also has some hidden advantages, particularly for macro photography where depth of field is allimportant. There is a balancing act between rendering the subject sharp and the background diffuse. The normal technique is to use a camera's depth-of-field preview button, at narrow apertures it often becomes too dark. The LCD on a D-SLR displays a bright image at any aperture, and can be used for depth-of-field preview. Just set your aperture, take your shot, assess the results (including the histogram) on the LCD, and make any adjustments.

Managing colour Chapter 4 discussed the effects of the white balance (WB) and colour matrix/space (CM) parameters. In certain situations, correct usage of these parameters can result in a greatly improved picture. So here are some hints and tips:

- To improve the impact of the picture, setting the WB to SHADE or the CM to sRGB will do that for you.
- In low light, setting WB to SHADE will improve the mood of the image. However, setting sRGB in red light will be overpowering.
- For natural skin tones, it is best to use a custom tone curve. For most of us, however, a CM of Adobe 1998 and WB of DAYLIGHT/AUTO will give natural results.
- In overcast conditions, sRGB can improve the colour of the image, as can WB CLOUDY.

Above Taken just after sunset, this shot shows how a D-SLR can capture detail in low light. At the time I failed to truly appreciate the scene – it seemed more important to get out of the water!

D-SLR parameters are readily changeable, so experimentation is easy (and fun). RAW shooters can do this at the browser stage, but JPEG shooters will have to take sequential exposures with the changes to see the difference, or use the RAW + JPEG option to give them the best of both worlds.

Managing your D-SLR in the field

So far we've covered the basics of what a D-SLR is, what it does and how it does it. We've also looked at the various ways of setting up your D-SLR, the choices you have to make and how to manage exposure. So now it's time to tie all of those together and examine the practicalities of managing your

Gradually we're forming a good methodology to get that perfect shot. So far we have developed the following process:

- Decide whether to use RAW or JPEG for the shot you want.
- Set up the D-SLR shooting parameters and WB according to the conditions.
- Set your desired ISO, being aware of any noise considerations with increasing ISO.
- Set the camera to aperture priority and dial in your desired aperture, which will vary depending on the shot you want to take.

I use f/4 for high action, f/5.6-f/6.3 for most wildlife, f/8 for studio work (depending on effect) and f/22 as a starting point for most landscapes.

- Compose and take the shot.
- Check the image on the LCD and view the histogram to judge exposure.
- Evaluate exposure, readjust exposure compensation if necessary and re-shoot.
- Re-evaluate histogram.

Below Taken in very overcast conditions, this image is nevertheless bright and vibrant – just like the two lion cubs.

Snapshot mode

As a wildlife photographer I have to be ready to shoot at a moment's notice. The same will be true of your photography, as opportunities are often fleeting. Therefore, I always have my D-SLR set up in what I refer to as 'snapshot mode' primed and ready to take a shot. The action may be so rapid that you do not have time to check the LCD histogram as you are shooting, but you should already have done this with your test shot. It is essential that you do this in a new situation. Here are the settings that I use for snapshot mode:

- Set to aperture-priority mode and f/5.6 to ensure a high shutter speed and good background blur.
- Set exposure compensation to -2/3 to ensure a slightly dark histogram this only applies if you have not had time to determine the correct exposure via the histogram.
- Set WB to AUTO for RAW workflow and SHADE for JPEG, assuming that you are outside.
- Set ISO to 200 to keep the speed high without generating too much ISO noise.
- Set autofocus to Tracking, AI or Continuous servo (or whatever it is called on your D-SLR). This is essential, as your camera will always focus quicker than you can.
- Highlight all autofocus points. Again, this is essential as you are putting the camera in complete control for maximum speed.

• Make sure you have space on your chosen storage card. This may sound simplistic but you'd be amazed at how easy it is to forget, with disastrous results.

If you have a lens-range switch, select the option that gives the shortest range to infinity. For example, if you have 1.5m to infinity and 4m to infinity, select the 4m option. This assumes that you will not have anything closer than 4m; if this is not the case, just keep it on the widest setting. The benefit is that the optics of the lens move less and achieve focus sooner.

Please bear in mind that these are only general suggestions, which are the result of my own experience. You may find that for your particular form of photography a higher basic aperture is needed – that must be your decision. The most important thing to bear in mind is the classic boy-scout motto: Be Prepared!

Managing images in the field

At this point our shooting begins in earnest, and some real problems can be avoided with careful planning. They can be grouped under the categories:

- Managing Storage Cards
- Downloading Images
- Preserving Battery Life
- Reducing Dust

Editing in-camera Each time you use your D-SLR you should format your storage card first. This removes any existing files that may prevent you from adding new images. In order for you to do this you should get into the habit of downloading your images as soon as you have taken them.

In Chapter 4, I showed a table highlighting the number of JPEGs and RAWs that can be squashed on to a 512MB CF card (see page 62). At some point the card will become full and needs to be downloaded. This is no problem at home, but not so easy if you are on commission in Outer Mongolia. The obvious solution is to carry lots of storage cards, which can be expensive.

The next best solution is to edit your images 'in camera' using the LCD screen and histograms to assess their quality. There are three main problems with in-camera editing:

- While you can judge exposure and composition via the LCD screen and histogram, you cannot judge focus to any accurate degree.
- D-SLRs provide a zoom function which helps with this, but at the expense of extra battery power. (The LCD drains the battery more than anything else.)
- Excessive usage of the LCD screen warms up the sensor and CF card, both of which can lead to problems with signal noise.

My policy is to keep in-camera editing to a minimum, only using it to remove the obvious howlers. All the rest should be left and only deleted in the digital darkroom, which will be covered later, see page Chapter 7. This means that you'll soon run out of space on the card, in which case you'll need to download your images anyway.

Image protection

Even the worst photographer in the world takes classic images at some point in their lives. With a D-SLR it is all to easy to delete these images with a lapse in concentration, but fortunately most D-SLRs provide an image-protection facility. This is a simple menu option, marked with a key symbol that prevents the image being deleted until it is uploaded onto the workstation. I don't recommend using this feature lots, but if you get a stunner then find the image-protect key quickly.

Downloading images in the field

There are three main options for downloading your images in the field. But remember, it's also a good idea to have enough cards to keep shooting while one is downloading. The three solutions are:

1) Laptops

Laptops are used to download images by many pros in the field, but generally only when they are within reach of civilization

Cards are normally downloaded via a PCMCIA adaptor, which can be extremely slow. Studio photographers often link their D-SLRs directly to a laptop, but for most of us this is impractical. The problem with taking a laptop travelling is usually a lack of power, too much weight, and fragility. I take a laptop with me for long trips, but only when I have a permanent base and can guarantee power. Another problem with laptops is their small hard drives, which can soon fill up on long trips. Fortunately several manufacturers make small, tough USB connected hard-drives that are designed to withstand the rigours of travel. I use a SmartDisk Firelite which has the added novelty of taking its power direct from the laptop's USB socket. When I get home I can quickly download all the images from this hard drive to my workstation; without it the only way of transferring them would be to burn lots of CDs which is a time consuming process.

2) Portable downloaders

Portable downloaders are the medium of choice for most outdoor photographers. They are really just miniature hard drives placed in a snazzy casing, usually with a menu driven application. They all have slots to take a variety of storage formats; for most you simply slide in your card and press 'Copy'. This usually takes several minutes to

download a 1GB card, the progress of which is indicated on an LCD screen. Once you are back at home you can usually hook these devices up to your workstation via Firewire or USB 2.0 and download the images straight away.

Drives come in many sizes; I use a 40GB Smartdisk FlashTrax which I chose for its reliability, spare batteries and car charger capability. The great thing about these units is their portability, compact size and large capacity. They are also only used for a single purpose, so hopefully should be more reliable than a laptop.

PRO TIPS

Avoid using the LCD screen on the downloader for editing/viewing images. It is about as useful as the D-SLR LCD screen for this and also consumes valuable battery power.

Many downloaders have a verify option which ensures that your files have been safely copied onto the hard disk. Making sure that they have been safely downloaded before deleting the contents of the card is advisable for recovery purposes, in case something should happen to the drive.

Of course, hard drives do fail, but I have used these devices to store my images on trips all over the world. I've had only one hiccup, with a previous device from another manufacturer, but the vendor was able to retrieve my data. If you do get a failure, don't panic, there is a good chance it can be rectified (see page 130).

3) Portable CD/DVD burners

The third option is a stand-alone CD/DVD burner. The advantage of this approach is that if you damage the unit, your images are still safe as they are stored on the CD/DVDs. They also appeal to those who need a CD burner anyway, as it can be used when attached to a PC or Mac. The downside is that you have to carry a stack of CDs with you and that CD units are notoriously fragile. Personally I always use a portable downloader.

Preserving battery life

The problem with D-SLRs is that they have heavy power requirements, more so in most cases than off-the-shelf batteries can provide. Most D-SLRs now have Li-on rechargeable packs, which extend their life, but most are lucky to cope with 500 shots on the same charge. Of course, this varies according to how you use the camera. For example, using tracking autofocus and a 500mm lens to cover a sporting event will be a huge drain on batteries. CMOS sensors

(see page 138) have helped this problem to a degree, but it still remains an issue that needs to be planned for.

To help preserve your battery life, forget about using all the snazzy playback options for your images, unless you are at home and the D-SLR is connected to the mains electricity supply. The worst culprit is the 'Review' option, which controls how the image is displayed on the LCD menu after you've taken it. Having it displayed after every shot is a waste of battery power and also causes heat problems. Switch this option to OFF and display the histogram when you need to by manually selecting it (see your manual for further details). The latest D-SLRs all have integral zoom functions that allow you to zoom into your images. In reality these are rarely useful and you should save image assessment until you have them on your workstation. After all, it is better to have enough power left for a few more shots.

Charging batteries in the field

Just a few words of wisdom from one who has stressed about batteries in some very remote corners of the world. One of my major concerns with a D-SLR is that you can never go more than a couple of days without access to power. Fortunately, I usually travel in an off-road vehicle, and therefore have access to power all the time. The problem is that many manufacturers do not provide a car adapter to power their cameras directly from the cigarette-lighter socket. Once again, working professionals have provided the solution, this time in the press sector. As they are always on the move it is a requirement that they charge batteries from the car. Most now use a device called an inverter. One end of this plugs into the socket and the other has a plug that matches your normal household one. While working in South Africa earlier this year I had a four-way power connector attached to the inverter, from which I simultaneously charged my batteries and powered my camera and downloader. These inverters are great; I used them for a month in Namibia last year when I was on the road constantly and without mains power. They are also very cheap!

Reducing dust Dust is the enemy of D-SLRs, and the sensors just seem to attract it like a magnet. The penalty for not cleaning your sensor

- just as for not keeping your lenses spotless - is hours of tedious tidying up using a program like PhotoShop.

All D-SLRs provide a way of accessing the sensor so that you can clean it, usually via a dedicated menu option. The Olympus E1 has a smart internal 'supersonic' cleaner that vibrates the sensor when the camera is turned on to shake the dust loose.

Most D-SLRs basically perform a mirror lock-up, revealing the sensor to the outside world and all that lovely dust. To be honest it is usually not the sensor at all, but the low-pass/anti-alias filter that is revealed. If you have a D-SLR without such a filter then you must be extra careful, as your sensor is completely exposed. Whatever your setup, adhere to the following rules and you can't go far wrong:

- Never use a cloth.
- Never use your fingers.
- Never use lens-cleaning fluid.
- Never use a can of compressed air as these spray water droplets.

Camera manufacturers will charge a lot for cleaning a sensor, but there are two really simply ways to remove dust:

• Use an air blower. This is much more powerful than a blower brush, and it will get rid of all but the most stubborn dust. Just remember to hold the camera upside down to let it fall out. As soon as you've Right This image, which was taken in the Masai Mara, shows the effect of dust on the D-SLR. I had cleaned the camera a few hours previously and the damage was caused by just one change of lenses in a dusty vehicle.

finished, put a lens on the camera to stop any more dust sneaking in.

• Minimize it in the first place. Use the air blower to clean the lens element that attaches to the camera, as dust on this will fall straight onto the sensor during exposure. Fragments will also fall from the lens each time you attach it to the camera body, but there is little you can do to avoid this.

In a dusty environment don't even consider changing lenses or using the air blower (it will simply blow dust onto the sensor) – just resign yourself to workstation time.

If you clean the sensor and lens often, using an air blower as described, your time spent in PhotoShop will be greatly reduced.

.....The Bottom Line

Managing lockout

Chapter 2 covered the issue of buffers within the D-SLR (see page 34). To recap, the buffer is a temporary store for your images before they are written to the storage card. It allows you to shoot a burst of images, how long depends on which D-SLR and storage format you use. Once the buffer is full the shutter functions lock while the D-SLR writes your images to the storage card (this is termed 'lockout'). Depending on your D-SLR, you then have a short wait while it writes the whole buffer, or an even shorter wait if it frees up buffer space as it goes.

For normal shooting, it is unlikely that you will ever encounter lockout, as the time between consecutive shots is long enough for the D-SLR to process files. The problem only arises when you shoot a continuous burst, perhaps of a bird in flight or your kids playing in the garden. Nothing can be more infuriating than missing a great shot while 'Busy' flashes at you in the viewfinder. Due to the unpredictability of nature, lockout affects me perhaps more than most

photographers, but I have learnt to deal with it and manage its effects. Here are my hints and tips:

1) The right tool for the job

Obviously it is important if you are a high-action photographer, you need to have a D-SLR that is right for the job. High-throughput D-SLRs with large buffers and fast drives are great, although some make a sacrifice in terms of resolution.

2) Shot selection

In my previous book, Life in the Wild: A Photographer's Year (ISBN 1 86108 268 1), I described how using medium format gave my photography a new edge. Instead of relying on a fast 8-fps motordrive to get me the shots, I had to use a 2-fps drive and cope with slower autofocus. It made me think about shot selection and capturing the image that I actually wanted. This has helped me a great deal with managing D-SLR lockout, as now I only shoot when the picture looks

PRO TIP

If you are travelling and planning to use chargers, it pays to double up on all cables – they can easily get damaged and may be difficult to source locally.

.....The Bottom Line

good. No more blasting away and hoping; I pick the shot I want and nail it. Cutting down on unwanted images frees more space for the best shots and means less time spent in front of the computer. Here are some practical tips to help you shoot fewer unwanted images:

- If you are tracking a moving subject and your autofocus doesn't lock on to it, don't shoot it. No amount of sharpening will be able to rescue an out-of-focus shot.
- Watch out for hotspots (use the LCD display to verify this if necessary). Move position if you have any, as they will detract from the final shot. If you can't move then wait until your subject does.
- Don't bracket your exposures. You should have already determined the correct exposure with the histogram. Slight adjustments can be made in the digital-darkroom.

Chapter summary Most of the information in this chapter should become second nature. Until then, here is a summary of the main points:

LCD screen

- You can't judge the exposure of an image based on how it appears on the LCD screen. Just use it for basic composition and for checking background distractions.
- Don't use the LCD screen too much. It drains the batteries and heats the sensor and can lead to increased noise in your images.

• Preserve battery life, by turning the LCD Review option to OFF.

Histograms

- The LCD histogram is the best way to determine exposure.
- Try to shoot a histogram where the peak is slightly left of centre.

Dust

- Only clean the camera's sensor with a manual air blower; never touch it or use compressed air.
- Ensure all lenses are clean.

Field exposure guide

- Use the PROTECT function of your D-SLR to prevent your best images being accidentally deleted.
- Always format your storage cards before each new use.

Managing lockout

• Be selective – only shoot the picture when it looks good, don't just blast away and hope.

Managing colour

• Experiment with the WB and colour matrix settings.

Below Sometimes it is best to let nature provide the colours that you need. In order to accentuate the effect of the late evening sunlight on the grass I took the shot from a low angle.

The digital darkroom

No matter how careful you are about shot selection, the temptation to take pictures with a D-SLR is overwhelming.

Not only is it fun to use, you can take as many pictures as you want without any additional cost – or so you think. The hidden cost is processing

The more your workstation fills up, the less space is available for your masterpieces and the slower it will run. Eventually it will grind to a halt, which is why it is important to use an image workflow.

JPEG workflows have the shortest shoot-to-print time, and the simplest workstation processing, while RAW workflows take more time. If you asked ten photographers about their workflows, they would offer ten different solutions. There is no perfect way to edit your pictures, only the way that is best for you. Therefore I have showcased several approaches, from which you can choose the one that suits you best.

Common ground

Whether you choose the simplest or the most advanced editing workflow, there are some basics that you need to be aware of first.

The browser The browser is key to managing images. They are usually graphically based, displaying all your images as thumbnails using a standard directory tree structure.

All D-SLRs are supplied with a browser. Some are useful, while others make the whole editing process overly complex. The first JPEG workflow that I will outline is suited to any of these, although the examples shown use Nikon View. A simple RAW workflow could also use these browsers, (see page 116).

Some camera manufacturers offer add-on browsers, but most professional photographers use independent browsers for the RAW workflow. I use RawShooter PRO but it is a personal choice and there are many competing applications that others prefer.

The ability to adjust shooting parameters has been highlighted throughout as a major benefit of the RAW workflow. This may have made the browser sound complex; it is in fact quite simple. Provided your D-SLR is set up correctly, the changes that you make will be minor, and a browser is perfect for the job. If you need to do some more extensive manipulation, use the browser to provide the basic image as a starting point.

Below This shot shows CaptureOne D-SLR. It's flexible, simple to use and produces great results.

The image-editor

An image editor's primary job is to clean and colour correct an image ready for printing and/or distribution. Its secondary function is to allow the manipulation of an image to your heart's content. You can stretch, shrink, re-colour, blend, blur or make water droplets from pictures, to name but a few techniques. The only limit is your own imagination.

Adobe PhotoShop dominates the professional photography and graphics market and provides seemingly limitless manipulation possibilities, but at the cost of several hundred dollars for a licence it's expensive for an amateur photographer. The next pricebracket down covers image editors like JASC Paint Shop Pro and Adobe PhotoShop Elements. Both are

excellent packages, providing everything necessary for all but the most demanding amateur photographer. While owning the full version of PhotoShop may be seen as better, most of its users only ever use a tiny proportion of its amazing functionality and would be equally happy with PhotoShop Elements or Paint Shop Pro.

For the vast majority of digital photographers an editor like Adobe PhotoShop Elements or JASC Paint Shop Pro will be more than sufficient for your needs.

.....The Bottom Line

EXIF Data

File: c6500.tif.tif File size: 18.0MB

Image Serial Number: 175-7522 Camera Model: Canon EOS 10D Camera serial number: 0230102575 Firmware: Firmware Version 1.0.0 Date/Time: 1980:01:01 00:02:30

Shutter speed: 1/640 sec Aperture: 11.0 Exposure mode: Av

Exposure compensation: -2/3

Flash: Off

Metering mode: Evaluative

EXIF, metadata or shooting data

As an author and a regular contributor to magazines, one of the banes of my life is trying to remember shooting information for captions. The D-SLR records all the shooting information for every image and attaches it to the images. This can be displayed within any browser, image-editing program or operating system. This screen grab (left) shows the type of information recorded. If you are shooting RAW, this data can be accessed at any time from your browser.

Directory structure The directory structure that you use to store images on your workstation can be as simple or as complex as you like. The one basic requirement is that you separate out the original files (RAW or JPEG) that you've downloaded from any that you generate subsequently. Accidents happen and it's vital to have the original to revert back to.

At its simplest level, the directory structure can be thought of in the same way as an office filing tray – In, Pending and Out. In our case it will be Digital Original, Digital Pending and Digital Finished, as shown below.

RAW files or your original JPEGs from the D-SLR can be loaded into the 'Digital Originals' folder, while your processed/finished files reside in 'Digital Finished'. It is unlikely that you will download and process all your images into 'Digital Finished' in one session, therefore anything that has been downloaded but is yet to be worked on/printed is moved to 'Digital Pending'. This method is simple and ensures that you don't miss a vital file.

- D-SLR Images
- Digital Originals folder
- Digital Pending folder
- Processing
- Digital Finished folder

Image download The first step of any workflow is to copy your images onto your workstation's hard drive. It is much quicker – and safer – to work with your images if they are stored on your workstation than on a portable storage device or storage card. Getting your images onto the workstation is a simple task. Most photographers use their browsers to manage this process. The simplest way of getting your images onto your workstation is to use its 'drag-and-drop' capability.

The image files sit on a storage card, which is inserted into a Firewire card reader connected to the workstation. The files are simply selected and dragged into the 'Digital Originals' folder on the workstation. If you have your D-SLR connected directly to the workstation, or are downloading from a portable storage device, the directory structure will look identical. The workstation sees only an external hard drive, not the device that is wrapped around it.

An alternative is to use the visual look and feel of a browser, such as Adobe PhotoShop Elements' file browser.

Numbering considerations

The D-SLR gives a number to each photograph, and this sequence resets itself when you change cards or when it reaches its limit. A good way of avoiding repetition is to use a more flexible numbering policy than that provided by the D-SLR. The system you choose is up to you, but here are a few suggestions:

• Limit filenames to eight characters. When you burn a CD, there are two main format options: Joliet and ISO 9660. The default is usually ISO 9660, which allows your CD to be read by most, if not all, PCs and Macs. When I send images to clients they are always on ISO 9660 CDs. The downside is that you can only have eight-character filenames. The Joliet format does not have this filename restriction, but has limited distribution.

• Choose a name that is simple and will last. The most common conventions are to use either eight digits (i.e. 12345678), or a combination of one letter and seven digits (i.e. A1234567).

Editing images This is the most subjective area in the whole book, but when you edit your work it pays to be objective. Key factors such as the accuracy of the focus should be carefully checked. If these elements aren't right then trash the image.

Composition isn't so important as it is very easy to crop an image to make the composition more attractive using some pretty simple PhotoShop tools. But the real shockers are usually easy to identify; the problem often comes when trying to assess detail. Here are a couple of ideas that you might find useful when comparing images.

Right I managed to capture this hawk owl at the moment of impact. Setting up the shot beforehand, I selected a shutter speed of 1/4000sec and set my focusing to AI servo to track the owl all the way. It still required split-second timing, proving that digital doesn't take all of the skill out of photography.

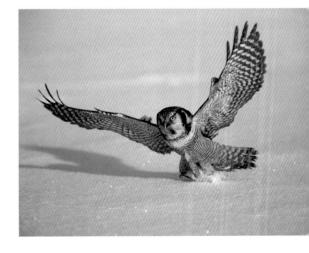

Browser slideshow Most browsers have a slideshow option, see below opposite, which is a great way to edit your work quickly. Select all of your images, choose the slideshow and they should appear full screen. JPEGs will load straight away, while RAWs are temporarily converted to TIFFs with the shooting parameters applied. Images that don't make the grade can either be deleted immediately or marked for deletion later.

PhotoShop tile Most of my editing time is spent assessing 'similars'. The screen-grab (right) contains two images that looked identical when viewed in the browser. I have used the PhotoShop tile option to display them side by side. Then I zoomed in on a similar area of both images. The image on the right is the sharpest. Everything but the best needs to be deleted.

16-bit editing PhotoShop allows you to work with images in either 8-bit/channel or 16-bit/channel mode. Using 16-bit mode means a smoother transition between colours, and in theory a better quality end result. The problem is that converting a file to 16 bits doubles the file size, which may slow your workstation down. If you want to manipulate an image in PhotoShop, convert it to 16 bit, work with it and then re-convert it back to 8 bit. Most browsers allow you to convert a RAW image to 8 or

16 bits, so it makes more sense to do it at the browser stage with the full RAW data.

Below The PhotoShop tile option, though not as quick as a browser slideshow, allows you to view images in much greater detail – particularly useful when comparing two very similar shots.

Right 16-bit editing is the only way to preserve the subtle colours of images like this rainbow taken in the Masai Mara.

Simple JPEG workflow

This workflow is the simplest and has the shortest time between getting the JPEG onto the workstation and printing out a finished image. This suits a lot of amateur photographers who simply want to enjoy their photography and get some nice prints with the minimum of fuss. It requires no intensive computer knowledge and there is no need to purchase any additional software, as everything needed comes supplied with the D-SLR. For the purposes of this example I will use Nikon View, but

you could achieve the same with Fuji FinePix Viewer or any other manufacturer-supplied offerings.

Step 1: Download image files to workstation The first step is to download the files from the storage card onto the workstation. The browser window looks as shown in the screen grab below.

Using the tree structure, I selected all the JPEG images on the storage card, and dragged them into the 'Digital Originals' folder.

Below The first step in any workflow is to download your images.

Step 2: Delete shockers Now it's time to identify and delete the shockers. The best policy is to set the browser to display the thumbnails at the maximum size.

At this stage it is impossible to tell if an image is out of focus, so look for the obvious shockers, like those showing a blank frame or severe exposure. I found three shockers in this selection (right) then selected and deleted them.

Step 3: Image zoom Now use either the slideshow function or just double click on the image to get a full screen representation of it, as shown below.

Simply scroll through the images, using the zoom function to inspect fine details at 100%, and refine the selection of images for deletion. When you find shockers delete them and move onto the next.

Below Blow your image up to full screen to examine its fine detail.

Above **Delete your shockers otherwise** they will take up valuable space.

Step 4: Minor corrections Now all the shockers are gone we only have the good stuff left. While most are probably OK, some will need minor corrections such as a little brightening. Most browsers allow basic editing like this, usually by launching to another editor window, as shown on page 110.

Corrections are made with a slider. Make sure that you activate any 'preview' options so that you can see the result of your changes. Here I have changed the brightness and added some red to the orchid's colour. Some browsers, including Nikon View allow you to launch straight into PhotoShop. This can also be used to 'clean' the images of dust and scratches before printing.

Above Most browsers allow some minor corrections to be made.

Below Specifying printer, monitor and workspace profiles helps to get the best finished result.

Step 5: Printer profiles This method works best if you specify a colour matrix/space parameter of sRGB in your D-SLR. Since your inkjet printers will use a basic sRGB profile (if you are unsure, try assigning them one from their properties tab), as long as you maintain sRGB throughout, the print should look OK. Of course, this depends on how the individual browser manages printers. The best way to find out is by experimenting. If you want to achieve more consistent results, turn to page 125.

This will not achieve perfect results, but they will probably be good enough. To improve your results most browsers let you specify profiles for your monitor, printer and workspace as shown below.

Step 6: Renaming and moving a printed image If you have changed the JPEG file, you obviously need to save it to record those changes. This also provides an opportune moment to rename the file, as shown below.

The most important point to remember is that saving a JPEG will degrade it slightly, so set the quality option to its maximum. At this quality level the file will be visually lossless as discussed in Chapter 3.

In order not to overwrite the original JPEG (assuming that you didn't rename it), save this file to the Digital Finished folder. If you intend to perform any further manipulation, it may be advisable to save it as a lossless TIFF, although this creates a larger file.

Step 7: Moving unfinished images If you do not intend to process and print the remaining images in the 'Digital Originals' folder until later, move them into the 'Digital Pending' folder. This frees up the originals folder to receive more images as you take them. Don't forget, however, to go through the pending folder periodically and finish off everything. This is good management practice and prevents a backlog from building up.

Below Save your JPEGs at maximum quality so they don't degrade visibly.

PhotoShop JPEG workflow

This is a slightly more complex workflow than the previous one, and it is designed to retain the original image quality of the JPEG file for the purpose of further manipulation. It is based around the PhotoShop 7.0 File Browser, which has really changed the way that this product can be used. Note that PhotoShop Elements has a virtually identical browser and so this workflow applies just as much to this product.

If you use Elements for this workflow you might also want to consider Adobe PhotoShop Album, as they work well together and perform a lot of complex tasks with just a few mouse clicks.

Step 1: Download image files to workstation

The first stage is to get the JPEGs from the storage card onto the workstation. The PhotoShop File Browser is used to display the directory tree, as shown below.

As always, select all the files from the card and drag them into the 'Digital Originals' folder. Sometimes the PhotoShop browser can be slow to react to changes, so if it doesn't show the card reader when it is first attached just hit refresh.

Below The directory tree is displayed showing files being downloaded into the 'Digital Originals' folder.

Step 2: Delete shockers The next step is to delete the obvious shockers, see above. On my monitor I could clearly see that in one image the expression on child's face wasn't one he'd like to remember, so I selected the image and hit delete. At this time it was the only really obvious shocker as I'd edited most in-camera (as the camera was connected directly to the mains it did not drain the battery). Normally there will be a few more than this, but for now this was all I could find.

Step 3: Image zoom Looking at the PhotoShop File Browser I could see three identical pictures in a sequence – two of them would have to go. There is no point keeping three shots of the same thing when one will suffice. I selected all three, dragged them into the main PhotoShop window and used

Above Look for any obvious flaws in images and delete those that don't make the grade.

Below Tile similar images so that you can examine them side by side.

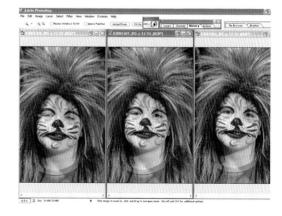

Opposite Saving files as maximum-quality JPEGs prevents too much data being lost through compression.

Above and right Save the image as a TIFF, in order to preserve the original quality, (above) then if you need to perform any PhotoShop colour correction convert the file to 16 bits/channel, (right).

Window-Documents-Tile to display them next to each other.

The image on the left captured a poor expression, so it was deleted. I then re-tiled the two remaining images, zoomed into the eyes with the magnifier tool, and saw that the one on the right was slightly sharper. Standing back it also has a better facial expression, and so I deleted the other. Finally, when all the editing was complete, I had four images left. The final stage was to save each one as a lossless TIFF.

This stage is vital to preserve the quality of the original image, although the TIFF is a whopping 31MB file (from my Canon EOS 1Ds), compared to the 5MB JPEG original.

This takes more processing power and storage, so it pays to edit them one at a time.

Step 4: Load image and convert to 16 bits/channel

In preparation for any colour correction, the TIFF is now changed to 16 bits/channel, as seen above. This doubles the file size so PhotoShop needs about four to five times more RAM than the image size to process it effectively. If you are constrained by RAM, I suggest that you consider avoiding saving the file as a TIFF and keep it as a JPEG. Changing this JPEG to 16 bits/channel will only increase the file size to 10MB, which is well

within the processing power of most workstations. If you take this approach, it pays to plan all your changes and make them all under one maximum-quality save, thus retaining the quality of the image.

Step 5: Finishing The cleaning and finishing stage is where the dust and dirt needs to be removed (see pages 122–3). Once cleaned the image is ready for any manipulation and/or printing in PhotoShop.

Before proceeding with manipulation, I suggest that a final 'cleaned' version be saved to 'Digital Finished'. This is vital because any subsequent manipulation in PhotoShop will be irreversible (unless you use the history function), and it is easy to overwrite your cleaned version with a manipulated one.

To save the cleaned image, first convert it back to 8 bits/channel and save as a maximum quality JPEG in the 'Digital Finished' file, above. If you intend to do some more manipulation, or are not worried about space, it makes sense to just save it as an 8-bit TIFF instead.

Step 6: Move unfinished images to 'Digital Pending'

The final stage of the workflow is to move any unfinished images into the 'Digital Pending' folder.

RAW image workflow

RAW images, because of their flexibility, take longer to process than JPEGs. The processing is not difficult, far from it; the challenge is to reduce the vast number of shots to a few good ones to work on. The RAW workflow can be thought of as a four stage process:

- Step 1: Image download
- Step 2: Image edit
- Step 3: Image rename and RAW back-up
- Step 4: Image processing/

Once we've identified our favourites then the fun part can begin – the actual processing and colour correction of each image to produce the finished result.

Step 1: Image download The first stage of any RAW workflow must be getting the actual RAW images themselves from the camera/portable downloader/CD or DVD onto the workstation. It is always best to load these images onto the workstation for reasons of speed and reliability, rather than working directly from the storage media itself. There are several products to assist you with this, but perhaps the easiest is to use either Windows Explorer or MAC OS.

Once the images are on the workstation I like to create a temporary back-up, just in case of a hard disk crash during processing.

OK so it seems like overkill but often I've risked my life for these images and have been the victim of a hard disk crash before. For backup Luse an external 250GB USB 2.0 connected hard-drive; if you originally uploaded your images from a portable downloader device then this can be used as the back-up copy (provided you don't take months to do the initial edit!). One last thing, remember that this is a temporary back-up of all the RAW images from a shoot; after stage 2 of our workflow is complete a much smaller, and perhaps more permanent, back-up will be taken of the core/favourite images.

Step 2: Image edit The goal of this step is to reduce our vast number of RAWs into a small workable number; similars and duplicates must be assessed to pick the best, and out of focus or poorly composed shockers must be deleted. There are several tools that can be used to achieve this:

The slideshow The browser slideshow is a superb tool for editing. It's basically a full screen display of each image, which allows you to see all it's good and bad points with the minimum of effort. Most slideshows allow you to tag an image for deletion later; this is usually via mouse click or a slideshow icon. This means that you can go through the slideshow tagging all the shockers then delete

them all together at the end, without the need for pen and paper! Trust me, using a slideshow will vastly decrease the number of images to process and I suggest going through the slideshow a number of times to be sure. I actually use this method when on safari; after each game drive I use the slideshow to delete the rubbish and identify the keepers, which I then back off to a portable hard drive for processing at home later.

The problem with using a slideshow is that RAWs need to be converted to JPEGS or Tiffs for full screen display. In real-time this is usually far too slow, with the exception of RAWShooter that offers virtually instantaneous conversion. Most browsers however rely on a JPEG for their slideshows to work effectively. This is no problem for more recent D-SLRs that have an embedded JPEG in the

RAW image already but for other D-SLRs it can cause a problem. Most photographers use one of two solutions:

- Set the D-SLR RAW Format option to RAW + JPEG SMALL. This means that for every RAW file a small JPEG will be created. There is no need to have a large JPEG created as for our editing purposes a small one will fill the screen perfectly. The downside of this approach is that the JPEGs take up space on the card, hence reducing the total number of RAWs that can stored. To be honest this is pretty minimal and on a 1GB card its small enough to be negligible.
- Create temporary proofing JPEGs via the RAW browser; most have the ability to do this. Since it can take quite some time it's best to convert them all in batch.

Of course the second option takes a lot more time and therefore most digital photographers use the RAW + JPEG SMALL method (if they can't just use the RAWs).

Left Using the slideshow option is a great way of editing your images in the RAW workflow.

Editing similars Slideshows are great for identifying shockers but they are useless for comparing several similar images. With increasingly fast D-SLR burst rates we all take more and more similar images. Some will be sharp and some not, but normally one will stand out from the rest. We need to find this one and save it for the next stage of the workflow, discarding all others in the process.

There are several approaches to this. One approach, is to use a direct RAW vs. RAW display which allows them to be compared at high magnification to identify the sharpest. This is a very quick way of identifying the best from a small group of similars.

Another approach is to use the JPEGs from the slideshow (created or otherwise) and tile them (see page 113) against each other in an image editor such as PhotoShop.

To tile images effectively, zoom all images to 100% and compare vital elements of the subject, for example eyes and facial features. Some will be obviously less sharp than others, make a note of these for deletion later and close their

windows. This process will eliminate the weakest images leaving only the one that we want to keep. All the others in the sequence, RAWs and JPEGs, can now be deleted as we have identified the best. If you've opened PhotoShop it's best to close it down before proceeding any further as it could well slow down your workstation.

Step 3: Image rename and RAW back-up Now we have cut down our RAWs to a manageable number it's time to rename them. RAW files generally need to be renamed because the filename generated by the D-SLR is both meaningless and limited in its upper numerical range. For example my Canon EOS 1Ds generates a filename starting 83DS followed by a 4 digit sequence number (0-9999). This means that after 9999 images have been taken on the D-SLR, the numbering is reset to 0001, an image number which already exists. There is no point renumbering the RAW files at first stage of the workflow, as many of the images at this point will be deleted during editing, which will leave a lot of gaps in your numbering and waste valuable sequence numbers.

Opposite Tiling images can be used to check them for exposure and focus.

Above Giving your images meaningful and easily navigable names is a crucial stage of any workflow.

Of course the hidden advantage of renumbering them at this stage is that the processed TIFF files will bear the same number as the RAW that created them, thus making it easy to locate the correct RAW file for re-processing if necessary. Just be careful to keep the RAW files in a different directory from any TIFF files as it is easy to overwrite them.

Creating a back-up Once the RAWs are renamed they need to be backed up. This is an essential step; all the effort of getting a great shot is pointless if you don't spend five minutes creating a back-up copy of it? Hard drives do fail and there is often no way back. The images are lost (unless you have a lot of cash). Follow the instructions for back-up in the next chapter.

Step 4: Image processing and conversion Now comes the fun bit, converting the RAW image data into a usable form. Think of it as your personal digital darkroom, with all the freedom and flexibility to be as creative as you want.

Most browsers look similar. The RAW image is selected and a large version of it, which I'll refer to as a dynamic preview, is displayed on the screen. Several sliders of varying complexity are provided to make adjustments to the image; these range from the basic shooting parameters such as white balance, to advanced tools such as shadow and highlight. The best browsers have a preview that changes instantly with any change in the slider value, the worst take several seconds to display any change.

Initially the preview is displayed with the original shooting parameters applied and in most cases this will be sufficient for most photographers. But a little adjustment here and there will always improve it and that is what the sliders are all about. The box opposite gives you a few pointers about how to get the most from each option.

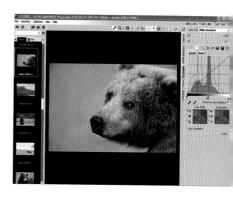

Above While each browser looks slightly different, most of the functions that they offer are actually the same.

WHITE BALANCE: Some browsers show white balance as the preset value from the D-SLR, but most display a colour temperature scale in Kelvin. When the preview is first displayed the white balance from the D-SLR is set, this can be changed using the slider. Most browsers also provide an eye-dropper for selecting a white point in the image, and also a 'magic wand'-style tool which guesses (often wrongly) the best white balance. White balance is a matter of personal preference, which is why I don't worry about it when shooting.

EXPOSURE: The most commonly used slider as this corrects any under- or overexposure in the RAW image. It is very difficult to correct overexposure as no slider can replace burnt-out detail, which is one reason why I recommend always slightly underexposing. Some browsers provide an advanced form of this with levels or curves, which allow more sophisticated corrections.

CONTRAST: This usually comes in several forms and controls the relative brightness of the dark pixels to the light pixels. Be careful when using this slider as overuse can harm image quality.

SHARPENING: All digital images need some sharpening to counter the effects of the low-pass filter, but the best place for sharpening is as the very last action in the workflow (in PhotoShop). If you are desperate to apply sharpening in your browser then be careful not to apply too much as nothing looks worse than an oversharpened image.

ADVANCED CORRECTIONS: Some browsers provide advanced corrections such as edge sharpening, moiré correction and extra contrast options. Experiment with these, preview the results and undo them if you wish.

The next level

The steps that I have shown here are the tip of the iceberg and most browsers allow you to perform all manner of operations. For most however a few tweaks here and there will suffice; I rarely spend more than 30 seconds per image and my images are in front of some of the harshest judges of quality in the world.

Once you are happy with your corrections then it's time to 'develop' them into TIFFs. Browsers provide a batch option, some process one at a time whilst others do it simultaneously.

Below Simple ways of cleaning up images is one of the advantages of image editors like PhotoShop.

Convert them as 16 bit/channel images if you intend to do any further image processing in PhotoShop; it will provide a wider dynamic range and a better quality result.

.....The Bottom Line

Cleaning converted TIFFs The final stage in preparing your converted TIFF is to clean up all the dust specs that the sensor has picked up. I'll run though a way of getting rid of them for those of you unfamiliar with PhotoShop.

First, load the image into PhotoShop and make it full screen. Then use the magnifier tool to zoom in, the dust spots become clear, as shown below left.

With the full version of PhotoShop there are several cleaning options available: the Rubber Stamp, Healing Brush Tool and Patch Tool. If you use PhotoShop Elements, however, you'll need to make do with a limited set of tools. For this example I chose the Healing Brush Tool. Once selected, you can alter the size of the brush to ensure that it is big enough to cover the dust spot.

For the best results the cursor needs to completely cover the dust spot, and ideally have some extra room too. For the Healing Brush to work well it is best to choose a sample from a similar area. Then just move the cursor over the dust

spot, click a couple of times, and it disappears. Repeat this for the entire image. At this stage your image is ready for manipulation. It is already in 16-bit mode, so further colour corrections can be carried out immediately. But first save the cleaned image to the 'Digital Pending' folder, overwriting the uncleaned TIFF.

specialists have written suites of custom PhotoShop actions that perform useful functions when added to the final stages of a workflow. These can be downloaded from the Internet for a small fee, and details can be found in the Appendix (see page 141).

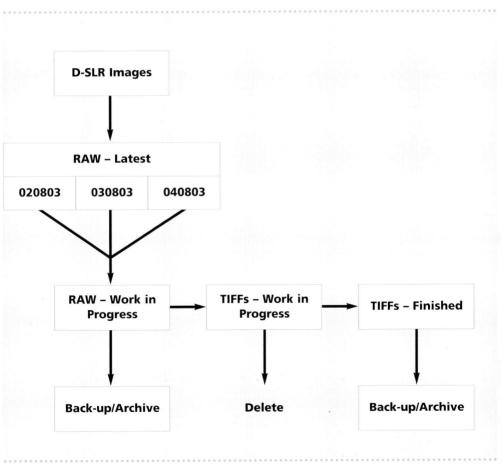

Calibrating monitors If you intend to send out your work to try to earn some cash, perhaps to photographic magazines, it is important to have your monitor colour corrected beforehand. Your image may look great on your monitor, but if it doesn't look good on your client's monitor too, your chances of making a sale are greatly reduced. Simply using an Adobe 1998 ICC profile attached to your picture won't work either, as it is your monitor's brightness and gamma settings that will cause any discrepancies. It may also have a colour cast that is not immediately apparent to you.

There is a choice of colour-calibration products ranging from simple software-based solutions like Adobe Gamma (PC) and Apple Calibrate (Mac), to software and hardware-based solutions like Optical Spyder and Lacie EyeOne. All the programs ask you to make various adjustments to your monitor to match certain targets as they are displayed, and this takes just a few minutes. Once completed, an ICC profile is saved and this describes the characteristics of your monitor

to applications like PhotoShop. which make allowances and display a consistent result. More complex systems like Optical use a combination of a software interface and a USB-connected hardware calibrator that fixes onto the screen. These systems are the most accurate as they measure the monitor's performance in detail using various standardized colours, but they come at a price (whereas Adobe Gamma is free with PhotoShop). One point to bear in mind: use either Adobe Gamma/Apple Calibrator or an external calibrator like Optical, but not both.

Once your monitor is calibrated you can be confident that anyone viewing your images on a different workstation will see the same results, provided that their monitor is also properly calibrated.

PRO TIP

Try to re-calibrate your monitor every month, and certainly re-calibrate it if you move its position in the room.

PRO TIP

Before calibrating a monitor, let it warm up for 30 minutes or so and avoid placing it next to a bright window. Getting consistent prints The perfect print (one that matches the monitor exactly) is almost impossible to achieve without a lot of hard work and reams of test paper. Often it is down to luck and persistence. Here are two approaches to printing that could help, one simple and one complex.

sRGB workflow By sticking to an sRGB workflow throughout your image processing you have a better chance of getting a print that looks like what is shown on the monitor. Everything must be set to sRGB: D-SLR colour matrix, workstation, PhotoShop workspace and the printer-supplied profile (usually sRGB-based anyway).

Printer-calibrated workflow

I have a fully calibrated printing system. At the heart of it is a set of ICC profiles specifically generated by a Gretag Macbeth package for the printer paper that I use. To generate the profiles I printed several samples using their supplied 'standard' images, scanned them in and fed them into the software, this produced an ICC profile for that paper. To print I use PhotoShop soft proofing (Proof option) to apply this profile to my image before printing. It is a lot of effort, and I sometimes wonder if it is worth it. An easier option is to buy and/or download printer profiles from the Internet, which are specific to a printer/paper combination.

Often I can get similar results using an sRGB workflow as a complex printer-calibrated workflow. At the end of the day, you should choose the option that suits your needs.

.....The Bottom Line

Below The timing here was a fine line between staying long enough to get the shot, but leaving while I still could! The D-SLR picked up great detail in low light ensuring that the risk was not wasted.

8

Storage, cataloguing & distribution

It is inevitable that one day you will accidentally delete a digital image. Whether it is a RAW, JPEG or TIFF, the end result will be that without a good back-up system, all your hard work with the D-SLR workflow will be wasted.

As I've already stated several times, using a D-SLR will greatly increase the number of pictures that you take. This means that the

Workstation hard drive The workstation hard drive seems the obvious place to store images initially, and is fine for most hobby

to clients or family members on the other side of the planet.

hard drive, then, if storage becomes a problem, use one of the methods outlined here.

Storage and back-up

RAW shooters need to be aware of this issue straight away. The combination of a RAW and a TIFF file from a 6.3MP camera is approximately 23MB, 1000 of which will take up 23GB of disk space – slightly more alarming. It's also a recipe for disaster having RAWs and TIFFs stored on the same hard drive.

If you followed the workflows of the previous chapter, you will now have a collection of RAW/TIFF or JPEG masterpieces that need storing somewhere. There are several choices: workstation hard drive, CD/DVD, or external hard drive.

CD/DVD I know some photographers whose storage solution is simply to write their RAWs, TIFFs and JPEGs straight to CD/DVD, and store nothing on hard drive. This strategy solves some of the problems above, but does have two serious weaknesses:

The problem with backing up is that it is a boring task that consumes valuable picture-taking time. In my experience, most photographers only consider backing up once they have already lost something. Backing up your image data, whether JPEG, RAW or TIFF, is a necessary evil of digital photography. It can be as simple or as complex as you need. My advice is to keep it simple and obvious, but remember: backing up data is not simply a case of copying it to CD and deleting the original; a back-up is a file that is kept separately from the primary storage of the file.

- Frequent use of a CD causes it to degrade more rapidly, and leaves it prone to damage.
- It is easy to build up a large stack of CDs, and finding the one that you want can become a hassle.

Above A beautiful roe buck in very late sunlight. Such encounters are priceless, hence the importance of backing up.

Fortunately there is an elegant solution to the second point. The basis of any back-up system needs to be a numbering system for CDs, so that you know exactly what is on a certain disc. At its simplest, a back-up strategy could be to write the names of all the files contained on that disc on the CD insert. The problem with this approach is that it quickly becomes difficult to sort through piles of CDs looking for a particular image. Fortunately, companies such as Adobe and Extensis offer image-management products that simplify back-up, cataloguing and management in general (see page 133).

The next level of backing up is to use DVDs, which have a capacity of 4.7GB, compared to 700MB on a CD. The big advantage of using DVD is that you will need a lot fewer than the equivalent storage space on CDs, but the risk of storing so much information in one place is relatively high.

A further danger is that the large capacity of a DVD can encourage you to wait longer to back up data so that you can fill a whole one. This may take several weeks, or even months, which defeats the object of making back-ups in the first place. If you choose to use DVDs for back up there are several varieties available, so be careful to get the right one. DVD-RAM seems to be increasingly popular for back-ups as it is a re-writable cartridge rather like a ZIP drive.

Speaking from a personal level, I consider CDs and DVDs to be an excellent back-up option, but I wouldn't use them as my primary storage tool. However, because I rely on my images for my living, I am particularly paranoid about losing them. For most photographers, especially those following the JPEG workflow, the CD/DVD route would be a satisfactory option.

Right I deliberately underexposed this shot of a robin to ensure that its side feathers did not burn out and the background did not become distracting.

External hard drives For those of you who, like me, want the best 'affordable' storage solution (as opposed to a RAID system, which costs thousands of pounds), an

125GB drive should be sufficient for many years of photography. External hard drives do present some problems, so here are some tips that I have learnt the hard way:

have seven 125GB Firewire drives, six of which are used to store TIFFs and one for RAWs. For most users, this would be excessive, and a single

site them separately.

• Hard drives are not designed to be moved around – do so and you're asking for trouble.

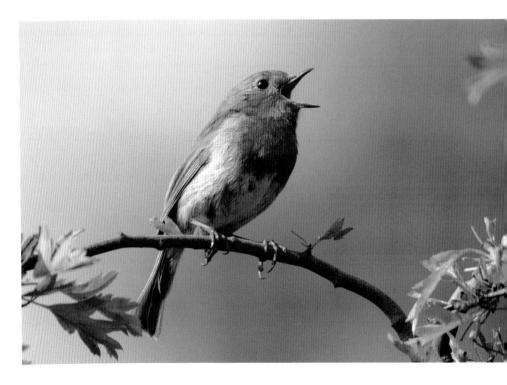

- When disconnecting the drive from Windows, it pays to ensure that you use the Safely Remove Hardware option from the taskbar. This helps prevent any problems.
- Only power up drives when you need to use them, and ensure that they are connected to the power source before inserting the Firewire or USB cable.

All hard drives can fail, and external ones are no exception. Once, the drive containing all my unprocessed RAWs failed. The drive had a threeyear warranty, which is great for replacing the equipment, but not so good for recovering the data stored on it. I called several data-recovery companies, who offered to retrieve my data from the defective drive for a large fee. Just as I was about to resign myself to paying out, a colleague told me about a datarecovery shareware product called PC Inspector. Within five minutes of downloading it from the Internet, it started recovering my files from the stricken drive, and within a day it had rescued everything. Details of the website can be found in the Appendix (see page 141).

Right Before I used a D-SLR, I would never have tried to shoot a dark subject against the light. When this wildebeest started running around, my D-SLR gave me the confidence to shoot it, and I was rewarded with a good action picture.

Cataloguing your images

In the old days of slides, it was relatively easy to find your images. All you had to do was to pull open the relevant draw of the filing cabinet and put a bundle of slide wallets on the light box. Not much has changed in the digital age, except that the filing cabinet has been replaced by cataloguing software on your workstation. The main problem when managing digital images is remembering where you put them in the first place. If you've chosen to run everything from CD, it will quickly become a

nightmare trying to find the CD with the images that you want. Of course, if you have relatively few images to manage, your PhotoShop/ Elements file browser will do a fine

that it is location independent – provided you allow the software to catalogue the image, it will always know where it is stored. This is very useful when dealing with CDs.

into calendars and cards. However, the main benefit of this software is

generally sophisticated enough to work this out and prompt you to find a new location.

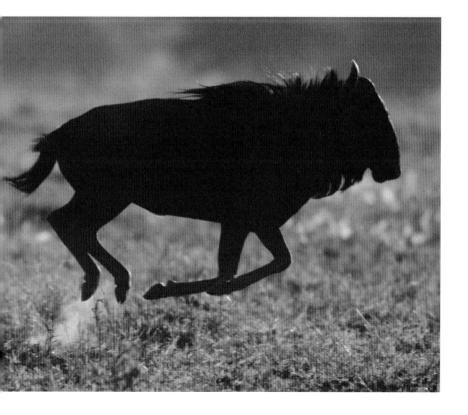

Cataloguing software

Cataloguing is a great tool here are two of the most common programs, Adobe PhotoShop Album and Extensis Portfolio.

Adobe PhotoShop Album This is a feature-rich product that provides basic yet functional image management via an easy-to-use graphical interface. As well as the basics, Adobe PhotoShop Album

provides some web applications, screen shows and the ability to produce cards or calendars.

Our database is arranged by species group, so we have galleries of lions, chimpanzees, and so on. They are all linked by keywords, such as 'cute' or 'endangered'. These keywords help to make searches more accurate and provide a quick and easy way of finding a suitable photograph for a particular use.

Left This screen shows a typical Adobe PhotoShop Album display of some of my latest work, taken in Africa. Selecting an image, such as the hippo, allows caption data and descriptions to be added to the image, plus any tags that will be used later for searching.

Right Album has a great archive capability whereby you can specify images to be written to CD, but with a thumbnail still retained on the hard disk. If you need the full-sized image, you'll be directed towards the CD that you created, which is why it pays to think of a clever naming standard for your CDs, particularly if you choose them as your primary storage location.

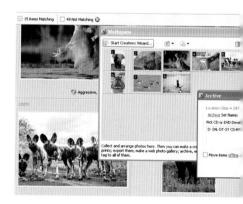

Extensis Portfolio Although I use some PhotoShop Album functions, my main library management tool is Portfolio, which currently catalogues over 15,000 images.

advanced photographers and commercial users.

You can see from the screen shots below that I use Portfolio to catalogue the location of the back-

Above and right Our database is arranged by species group, so we have galleries of lions, chimpanzees, and so on. They are all linked by keywords, such as 'cute', so one search will bring up results for many different species.

Distributing images

When you distribute your images you should be aware of image copyright and protection issues.

Image copyright International copyright is a very complex area, and its intricacies are beyond the scope of this book. However, as the photographer you will almost always own sole copyright of the image. Digital capture has made copyright infringement increasingly common and several times in the last year I have been told about images of mine appearing on various websites, and on each occasion I have spoken to the webmaster and arranged for their immediate removal. It's not that I am particularly touchy about the use of my images (I'm pleased to help several charities by allowing

them free use of my work), but I will not tolerate the use of my images without permission. We all need to be aware of copyright abuse. To limit the chances of your images being misused, you can take some simple steps:

- When displaying an image on the web, or sending one via email, make it large enough to be seen well, but too small to be used commercially.
- Watermark your images with the copyright symbol (©) and a phrase or your name that is written over the top of the image. This helps prevent unauthorized usage and can be done in programs such as Adobe PhotoShop. Mark a significant portion of the image, enough to prevent its misuse, but without spoiling its impact.

Right Here is one of my images, which at 300 dpi is large enough to print at A3. If I put this full-sized image on the web, you can bet that it would appear as a bootleg poster within a couple of weeks. Setting the longest side to 600 pixels, reduces the print size, and the file size is only 701KB. This is still too large, so I save as a JPEG Compression Level 5, which is easier to send by email and quicker to upload and display on the web.

Creating web galleries The Internet has provided us with a great resource to show our photographic work. The problem is that until recently it required some knowledge of HTML and JavaScript.

minutes. I have used this method many times with clients in remote countries, when sending them a CD would take days. On a more personal level, it's great for showing relatives your family.

excellent web-generation functions. Here is a typical web page generated by BreezeBrowser, which took all of 30 seconds to complete. Clicking on the thumbnails will display a watermarked, slightly larger image — a really nice and simple implementation to show your work. With some very limited HTML knowledge this could easily be expanded into a website featuring a number of pages.

Right Adobe PhotoShop Album provides some great web templates too, but my favourite is the Atmosphere gallery. Using specified images and some great themes, you can display a 3D gallery where you use the cursor to walk round – complete with musical accompaniment! It's a really fun tool and provides a neat way to set up your own online exhibition quickly and easily, complete with picture captions.

Above I often use the web-creation feature of Extensis Portfolio to create a small web page of my latest images. I can then quickly upload it and send clients an email with a link to the page. I find that this method works much better than sending out work on CD, as most clients have direct connections to the Internet and can view the page within seconds.

Left The punchy colours of an sRGB colour space/matrix profile (see pages 71–2), coupled with a WB set to SHADE (see pages 63–70) help this Masai jewellery to really stand out.

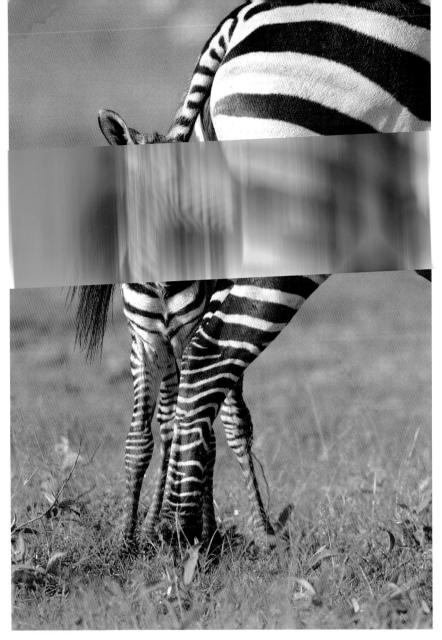

Above This portrait of a newborn zebra in the Masai Mara was surprisingly easy to expose for using a D-SLR.

Glossary

Aliasing The pixellated appearance of curved lines.

Aperture A small, circular opening inside the lens that can change in diameter to control the amount of light reaching the camera's sensor as a picture is taken. The aperture diameter is expressed in f-stops; the lower the number, the larger the aperture. For instance, f/2.8 creates a larger opening than f/8. See also shutter speed.

Buffer Memory in the camera that stores digital photos before they are written to the memory card.

Burning Selectively darkening part of a photo with an image-editing program.

of the two main types of image sensors used in digital cameras. When a picture is taken, the CCD is struck by light coming through the camera's lens, in the same way that would strike film.

CD-R CD-Recordable: a compact disc that holds up to 700MB of digital information. Creating one is commonly referred to as burning a CD. A CD-R disc can only be written to once, and is a good storage medium for digital photos.

CD-RW CD-Rewritable: similar in virtually all respects to a CD-R, except that a CD-RW disc can be written and erased many times. This makes them best suited to many back-up tasks, but not for long-term storage of original digital photos.

Chromatic aberration The red/green fringing that appears around a subject when the lens fails to bring red, green and blue to a single point of focus.

CMOS Complementary Metal-Oxide Semiconductor: one of the two main types of image sensors. Its basic function is the same as that of a CCD.

CMYK Cyan, Magenta, Yellow, Key (black). The four colours in the ink sets of many photo-quality printers. Some printers use six ink colours to achieve smoother, more photographic prints.

CompactFlash A common type of digital camera memory card, about the size of a matchbook. There are two types of cards, Type I and Type II. They vary only in their thickness, with Type I being slightly thinner.

Dodging Selectively lightening part of a photo with an image-editing program.

Download The process of moving computer data from one location to another. Though the term is normally used to describe the transfer, or downloading, of data

. Cype or cabing

technology for transferring data to and from digital devices. Some professional digital cameras and memory card readers connect to the computer over Firewire. Firewire card readers are typically faster than those that connect via USB. Also known as IEEE 1394, Firewire was invented by Apple but is now commonly used with Windowsbased PCs as well

Histogram A graphic representation of the range of tones from dark to light – sometimes for seperate colour channels – in a photo. Some digital cameras include a histogram feature that enables a precise check on the exposure of the photo.

IBM Microdrive An alternative form of digital-image storage media to a CompactFlash card. A Microdrive is literally a miniature hard drive, unlike a CF card, which uses solid-state technology.

Image browser An application that enables you to view digital photos. Some browsers also allow you to rename files, convert photos from one file format to another.

out extraneous detail, remove red-

Image resolution The number of pixels in a digital photo is commonly referred to as its image

eye and so on.

resolution.

Interpolation The mathematical process of expanding an image.

JPEG A standard for compressing image data developed by the Joint Photographic Experts Group, hence the name JPEG. Strictly speaking, JPEG is not a file format, it's a compression method that is used within a file format, such as the JPEG format common to digital cameras. It is referred to as a 'lossy' format, which means some quality is lost in achieving JPEG's high compression rates. Usually, if a highquality, low-compression JPEG setting is chosen on a digital camera, the loss of quality is not detectable to the eye (see pages 48-59).

LCD Liquid Crystal Display: a lowpower monitor often used on the top and/or rear of a digital camera to display settings or the photo itself.

Low-pass filter The filter that is placed in front of the sensor in order to minimize the effects of aliasing and moiré.

Megabyte (MB) A measurement of data storage equal to 1024 kilobytes (KB).

Megapixel One million pixels.

Moiré The wavy pattern that is caused by the interference of a subject pattern and the pixel grid.

Pixel Picture Element: digital photographs comprise millions of them; they are the building blocks of a digital photo.

RAW The RAW image format is the data as it comes directly off the CCD, with no in-camera processing performed.

RGB Red, Green, Blue: the three colours to which the human visual system, digital cameras and many other devices are sensitive.

Saturation How rich the colours are in a photo.

Serial A method for connecting an external device such as a printer,

scanner, or camera, to a computer. It has been all but replaced by USB and Firewire in modern computers.

Shutter speed The camera's shutter speed is a measurement of how long its shutter remains open as the picture is taken. The slower the shutter speed, the longer the exposure time. When the shutter speed is set to 1/125 or simply 125. this means that the shutter will be open for exactly 1/125th of one second. The shutter speed and aperture together control the total amount of light reaching the sensor. Some digital cameras have a shutter priority mode that allows you to set the shutter speed to your liking. See also aperture.

Thumbnail A small version of a photo. Image browsers commonly display thumbnails of photos several at a time.

USB Universal Serial Bus: a protocol for transferring data to and from digital devices. Many digital cameras and memory card readers connect to the USB port on a computer. USB card readers are typically faster than cameras or readers that connect to the serial port, but slower than those that connect via Firewire.

White balance A function on the camera to compensate for different colours of light being emitted by different light sources.

Appendix

Useful companies:

PC Inspector

CaptureOne

www.c1dslr.com - software

Extensis

www.extensis.com - software

FourThirds

www.four-thirds.com - technology

Foveon

www.foveon.com - technology

Fujifilm

www.fujifilm.co.uk – UK www.fujifilm.com – USA

Kodak

www.kodak.com - Worldwide

Konica Minolta

www.konicaminolta.com - Worldwide

Nikon

www.nikon.com - Worldwide

Olympus

www.olympus.com - Worldwide

Warehouse Express

www.warehouseexpress.com - retail

General photography:

Noel Carboni

www.actions.home.att.net – PhotoShop actions

Rob Galbraith

www.robgalbraith.com – technical discussions and information

Luminous Landscape

www.luminous-landscape.com – product reviews and information

Andy Rouse

www.andyrouse.co.uk

The IQ test

www.wyofoto.com

Photography publications:

Photographers' Institute Press

Photography books and magazines www.gmcbooks.com

Index

backing-up 25, 46, 47, 119, 127–9
batteries 57, 96–8
Bayer mosaic sensors 26, 27
bellows hood 90
blurring 31, 81–2, 90
bracketing 67, 100
brightening 87
browsers 105, 107, 109
slideshow 107, 116–17
buffers 34–5, 38, 39, 50, 99

camera shake 26, 28, 81
card readers 40
cataloguing 25, 47, 78
software 130–3
CDs/DVDs 46, 47, 127–8
burning/burners 46, 47, 97, 106
chromatic aberration 31
CMOS sensors 97
colour calibration 124
colour correcting filters 63
colour management 45–6, 91, 101

colour mode 72
colour ranges 56
colour temperature (CT) 63–4, 69–70
colour-processing parameters 71–3
compact cameras 37
CompactFlash (CF) cards 38, 77
compression 53, 55, 56, 62
computers see workstations
contrast 55, 121
copyright/distribution 134–5
cropped sensors 28–9

data recovery 130
depth of field 83, 90, 91
diffused lighting 68
diffusers 35
digital darkrooms 23–31
digital film 24, 38
downloading images 23, 40, 94,
105, 108, 112, 116
in the field 95–6
dual-buffer systems 34–5
dual-format (SD) cards 39
dust reduction 98–9, 101

expansion/interpolation 19, 20, 21, 31, 73
exposure 81, 93, 101, 121
compensation 35, 93, 94
histograms 85–90
ratios 84
Extensis portfolio 133, 136

f-stops 83–4, 93 files: directory structure 105 numbering 78, 106 renaming 111, 119 filters 30, 85, 98 Firewire connections 23, 44 flash units 35 focal length 28–9, 31 focus/focusing 94, 107

image quality (IQ) 16, 18–19, 52–4, 61–3, 111 improving 58 and ISO ratings 75

hard drives 43–4, 96–7, 127 external 43–4, 127, 129 high-action photography 59 highlights 87 burning out 36, 87, 88, 89 LCD alerts 36 histograms 85–90, 94, 101 evaluation 86–7, 93 in the field 88–90 hotspots 100

IBM Microdrives 38-9, 77 ICC (International Colour Convention) profiles 71-2 image editing 55, 103, 108-9, 116-19 cleaning up 122-3 finishing 115 workflows 108-25 image formats 23 dynamic ranges 56-7 file sizes 53 JPEG/RAW comparisons 49-59 losslessness 53, 63 RAW + JPEG 42, 52, 59, 63, 91 TIFF 49, 52-3 image management 128 in the field 94-101

JPEG imaging 23, 39, 63, 91 editing/re-saving 53 files sizes 42–3, 53 PhotoShop workflow 112–15 tips 57 workflow 49–50, 63, 103, 108–11

landscape photography 29, 59, 83 LCD screens 3, 90–1, 100–1 advantages 15 and downloading 96 lenses: digital-specifications 33 focal length 28–9, wideangle 29, 31 zoom 27 light meters 85 light sources 63 lockout 34–5, 99–100, 101 long-exposure photography 55, 89 noise 75–7 low pass/anti-alias filters 30,

macro photography 91 matrix/space (CM) parameters 91 memory, buffers 34–5, 38–9, 50, 99 memory cards 14, 40, see also storage cards

snapshot mode settings 94 moiré patterns/correction 30-1, 121 monitors 45-6 software 58 Adobe Photoshop 31, 42, calibrating 124 motion photography 81-2 104, 107 BreezeBrowser 135 noise 16, 26, 55-6, 59 browsers 105, 107 high-ISO 74-5 caption data 104 noise-reduction technology 76–7 editina 104 Extensis SmartScale 21 optical filters 30 filters 63-4 Microsoft XP 41 overexposure 35, 86-7 PictBridge 23 **RAWShooter PRO 103** PCMCIA adaptors 23, 40, 96 pixels 16-17, 26, 30 sports photography 57 portable downloading devices 40 sRGB ICC profile 71-2, 125 portable storage devices 23 storage 57, 127-9 printers/printing 23, 125 buffers 34-5, 38-9, 50, 99 profiles 110, 125 cards 38-9, 94, 105 program modes 84 TIFF see RGB-TIFF RAW imaging 23, 39, 91 file sizes 42-3 underexposure 56 USB connections 23, 44 flexibility 55 quality options 62 workflow 50-1, 50, 103, 116-23 Video RAM 43 re-touching 16 resolution 17-18 web gallery creation 135-6 RGB-TIFF 49, 52-3, 122 white balance (WB) 14, 63-70, 91, 120 - 1scanning 19-20 auto white balance 65-6 scratch disk 43 bracketing 67, 69 sensitivity 74 fine tuning 69-70 sensors 16-17, 26-32 guide and examples 66–70 dust reduction 98 sensor 70 and JPEG imaging 55 settings 67, 68, 94 wideangle lenses 29, 31 and RAW imaging 50 sizes 28-31 wildlife photography 59, 85 workflow see JPEG or RAW imaging sharpness/sharpening 30, 121 workstations 23, 41-7 parameters 73, 121 shutter speeds 81-2, 84, 90 signal noise see noise zoom functions 27, 97, 109, 113-14